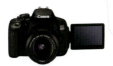

OLIVIA SPERANZA
THE MOVIEMAKING
WITH YOUR CAMERA
FIELD GUIDE

OLIVIA SPERANZA
THE MOVIEMAKING
WITH YOUR CAMERA
FIELD GUIDE

The **essential guide** to shooting video
with HDSLRs and digital cameras

Focal Press
Taylor & Francis Group

NEW YORK AND LONDON

First published 2013
by Focal Press
70 Blanchard Rd Suite 402
Burlington, MA 01803
Focal Press is an imprint of the Taylor & Francis Group, an
informa business

This book was conceived, designed, and produced by Ilex Press
Limited, 210 High Street, Lewes, BN7 2NS, UK

Publisher: Alastair Campbell
Associate Publisher: Adam Juniper
Managing Editor: Natalia Price-Cabrera
Editor: Tara Gallagher
Specialist Editor: Frank Gallaugher
Creative Director: James Hollywell
Senior Designer: Ginny Zeal
Designer: Graham Davis
Illustrator: Richard Peters
Color Origination: Ivy Press Reprographics

Library of Congress Control Number: A catalog record for
this book is available from the Library of Congress.

ISBN: 978-0-240-82425-3
eBook ISBN: 978-0-240-82459-8

Library of Congress Cataloging in Publication Data
A catalog record for this book is available from the
Library of Congress.

For information on all Focal Press publications visit our
website at: www.focalpress.com

Printed and bound in China

10 11 12 13 14 5 4 3 2 1

CONTENTS

Introduction 6

The Basics 8
Aperture 9
Shutter Speed 10
White Balance 12
ISO 13
Custom White Balance 14

Getting the Best Results 16
Camera Types 18
Camera Menu Setup 20
Information Display 24
Lenses 26
Crop Factor 28
Filters 30
Framing 32
Composition 34

Lighting & Audio 36
Hard & Soft Light 38
Types of Light Sources 40
Light Emission 42
Color Correcting & Styling Gels 44
Other Lighting Accessories 45
Three-point/Four-point Lighting 46
Catchlights 48
Reflector 50
Introducing Audio 52
Three Tips to Capture

Quality Audio	54
Polar Pattern	56
Common Types of Microphone	58
Microphone Orientation & Mounting	60
External Audio Recorder	62
Field Mixer	64
Why You Need a Preamplifier	65
Clapper Slate	66
Basic Tools	**68**
Support	70
Video Rig	76
Rig Accessories	78
Gear for Dynamic Camera Movements	82
Battery Power	86
Grip	88
Accessories	90
Memory	92
Shooting Video	**94**
Consistent Pre-production Aspects	96
Production	100
Types of Video: Event	102
Types of Video: Editorial	110
ENG in Compact Spaces	114
Tutorial	116
Types of Video: Documentary	120
Types of Video: Narrative	126
Types of Video: Music Video	132
Creating Standard Sets	138
Chroma Key	142
ReflecMedia's LiteRing	144
Shooting a Product Video	146
Focusing Tips While Shooting	150
Shooting in Low-light Conditions	152
Utilizing Depth of Field for Effect	156
Shooting Tips for Gear	158
General Shooting Advice	164
Post-production	**168**
Editing Software	170
Containers & Wrappers	171
Codec & Converting	172
Syncing Video & Audio	174
Editing Basics	176
Building a Sequence	178
Color	180
Finishing Up	182
Glossary	184
Index	188
Acknowledgments	192

INTRODUCTION

In recent years the shooting of high-definition video on DSLR cameras has exploded in popularity. One reason for this is the ability of DSLRs to capture a very shallow depth of field when filming, which in the past could only be achieved with expensive film cameras. Another huge advantage of shooting video on a DSLR is that many of the cameras that produce cinematic-quality footage are priced for the average consumer. The outstanding high-definition footage, large sensors, and low-light capabilities make the modern DSLR hugely desirable to filmmakers.

The first wave of DSLR cameras were built in a manner closely aping their film forefathers, with a mirror mechanism that reflects the image seen through the lens to the viewfinder, via the pentaprism. In the instant a photo is taken, the mirror flips out of the way and the light is exposed directly on the sensor; once the shutter is closed, the mirror returns to its position and the imaging sensor sees no light.

All that has changed now, thanks to Live View mode. Not exclusively for video, the principle behind Live View is simple; the mirror is held out of the way all the time, and the light travels through the lens directly to the imaging sensor. The digital sensor can relay the image to the LCD screen on the back of the camera, allowing it to behave with the simplicity of a compact, while retaining the sophisticated interchangeable lens mechanism of a DSLR. Indeed, some cameras forego the mirror and traditional viewfinder altogether—for example, the Micro Four Thirds system and other Electronic Viewfinder Interchangeable Lens (EVIL) or Mirrorless Interchangeable Lens Camera (MILC) systems—and much of what is discussed in this book applies equally to those cameras.

The Moviemaking With Your Camera Field Guide is intended to appeal to both first-time DSLR video shooters and experienced filmmakers who are looking to transition to shooting on a DSLR. This book contains

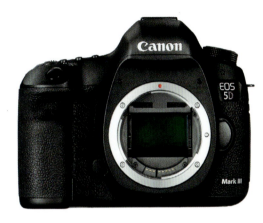

DSLR CAMERAS

Each type of camera has its own set of
pros and cons. For low-budget filmmakers
the relatively low price of a DSLR, coupled
with the quality of the footage it can record,
makes it an excellent choice.

the initial stages of setting up your
camera and how to use it properly,
to understanding the available tools
designed specifically to improve working
with DSLR video, as well as post-
production. It is my goal for this book to
help you in your career as a DSLR video
shooter and become the best you can
be at shooting and sharing your work
with others.

NEWER OPTIONS

The short flange distance of mirrorless camera
bodies offers some unique portability advantages.
The flexibility in lens design is also beneficial
for consumers.

The Basics

Getting the
Best Results

Lighting & Audio

Basic Tools

Shooting Video

Post-production

THE BASICS

To get the most out of your camera, you need a thorough understanding of how it captures video, and what effects different aspects of your camera and equipment will have on your footage. In this chapter I take you through what you need to know, covering everything from exposure to composition.

Aperture

The aperture is measured by the size of the iris within the lens. The iris is an opening that controls the amount of light that passes through to the sensor. Aperture numbers are often referred to as f-stops. f-stops are like fractions, moving from one to the next will either double or reduce by half the amount of light that passes through to hit the sensor. The larger the opening of the iris (wide open), the more light can enter and the number is represented as a small number such as $f/1.4$ or $f/2.8$. At a smaller aperture size (closed down), less light is able to enter and the f-stop represented is larger—for example $f/16$ or $f/22$.

THE BASICS

9

Getting the Best Results

Lighting & Audio

Basic Tools

Shooting Video

Post-production

Depth of Field

The aperture also controls the depth of field. When the aperture is closed down you will obtain a large depth of field. This means that your focus plane will be greater and, in effect, more of your shot will be in focus. When the aperture is wide open, a small or shallow depth of field is achieved. This means that only a portion of the picture will be focused and the rest will fall out of focus or become de-focused.

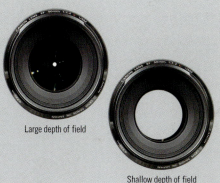

Large depth of field

Shallow depth of field

BOKEH

This term refers to the aesthetic quality of the blur that makes up the out-of-focus points of light in an image. Depending on the aperture shape and setting, your lens will produce different bokeh styles. The ability that DSLR cameras have to capture this effect is one of the main reasons why they are extraordinary for shooting video.

Shutter Speed

The shutter speed is the length of time that the shutter remains open for light to hit the camera's image sensor. Situations where a lot of light is available require faster shutter speeds to be correctly exposed than situations with low light, which need slower shutter speeds. Thus, adjusting your shutter speed will change the look of your video.

Setting Frame Rate for a Cinematic Look

Frame rate refers to the number of frames or images that are projected or displayed per second, and is measured in frames per second, or fps. When shooting with a DSLR, the basic rule of thumb to achieving a filmlike, cinematic look to your videos is to set your shutter speed to about twice the value of your frame rate. Setting your shutter speed at double the frame rate will give your video the smooth, cinematic quality that most videographers who use DSLRs want to create. For example, if you're shooting

24fps then it is recommended to set your shutter at 1/50 second. If you're shooting at 30fps, you should set your shutter speed to 1/60 second. At 60fps, your shutter will be 1/120 second. This is the rule for creating a filmlike look, but of course you should feel free to experiment with other shutter speeds.

Neutral Density Filter

Your shutter speed will make or break your film's quality. A slow shutter speed will give you a better effect, but in daylight shooting, using a slow shutter speed will overexpose your shots if your aperture is wide open. Adjusting your aperture to accommodate the slow shutter speed, will give you a correctly exposed shot, but it will lose the shallow depth of field that is often associated with a professional film feel. It's a conundrum. Since a wide aperture is necessary to keep a shallow depth of field, attaching an ND (neutral density) filter to your lens will cut down the amount of light entering and will allow you to keep a wide aperture with a slow shutter speed.

NEUTRAL DENSITY FILTER+

The ND filters act like sunglasses for your camera, these are vital when filming in bright environments. They are also used reduce the amount of light entering the lens to achieve a shallower depth of field.

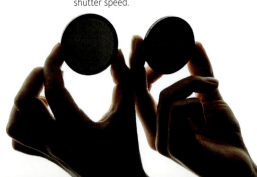

Rolling Shutter

When a video is shot on a DSLR, each line of pixels is recorded line by line to the sensor by a series of scans in which the camera rolls the shutter across the image area that is being exposed. Many DSLR cameras use a CMOS sensor, but when this is used to record movies, the light falling on the sensor is not read as a whole. As each line of pixels on the sensor is read one after the other in sequence, when panning quickly straight edges may take on a curved or even diagonal appearance, ranging from a skewed image to a wobble commonly referred to as the "jello effect."

Jello Effect

The rolling shutter method can make some perfectly straight objects appear to wobble, or turn wavy or shaky. In order to avoid this sort of distortion, panning and tilting slowly, and using a tripod is your best solution. Additionally, a shot including vertical lines will create a greater number of challenges with a rolling shutter. For more on this effect see pages 164–165.

FRAME RATE
DSLR vide footage recorded at 24fps will match the traditional speed of motion-picture film.

SHUTTER SPEED
Shutter speed is measured in seconds, or in most cases in fractions of a second. The larger the denominator the faster the speed, so for example, 1/1000 is much faster than 1/30.

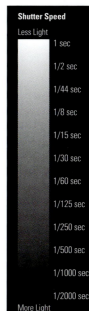

Shutter Speed

Less Light

1 sec

1/2 sec

1/44 sec

1/8 sec

1/15 sec

1/30 sec

1/60 sec

1/125 sec

1/250 sec

1/500 sec

1/1000 sec

1/2000 sec

More Light

White Balance

White balance is the process of removing incorrect color casts in your images. When white is captured as true white according to the light temperature in your given environment, the color of the picture will be true to what the human eye sees.

There are various settings that control white balance, and while these features are convenient, the Auto White Balance preset can produce unfavorable color casts that aren't true to the human eye. It's also key to remember that the camera's presets won't always render optimal results either. Manually dialing in your white-balance setting is always best, as this gives you full control of the final color result of your footage.

Kelvin Temperatures

The Kelvin temperature measures the relative warmth or coolness of white light. At a high Kelvin temperature, more blue tones are visible, while between 5000–7000 degrees K, the light we see is white. Once the Kelvin temperature dips down to the lower numbers, we see warm tones and reds. The following chart gives you a guide to the different temperatures produced by different sorts of light.

Color Temperatures of Common Light Sources

Color Temperature	Light Source
1000–2000 K	Candlelight
2500–3500 K	Tungsten Bulb (household variety)
3000–4000 K	Sunrise/Sunset (clear sky)
4000–5000 K	Fluorescent Lamps
5000–5500 K	Electronic Flash
5000–6500 K	Daylight with Clear Sky (sun overhead)
6500–8000 K	Moderately Overcast Sky
9000–10000 K	Shade or Heavily Overcast Sky

DSLR Presets

Your DSLR presets are designed to capture light at the following color temperatures:

3000–7000 K	Auto
5200 K	Daylight
7000 K	Shade
6000 K	Cloudy, twilight, sunset
3200 K	Tungsten light
4000 K	White fluorescent light
6000 K	Flash use
2000–10000 K	Custom
2500–10000 K	Color temperature

ISO

ISO (International Organization for Standardization) expresses how sensitive the image sensor is to the amount of ambient light present. With a higher ISO setting, more sensitivity is introduced to the image sensor, making capturing images in low-light situations possible. Your ISO setting will also determine the aperture and shutter speed combinations you should set to get a correct exposure. Boosting your camera's sensitivity to light helps you to keep the correct exposure in situations that require more light.

There are a few precautions you must take since having too high of an ISO setting can introduce noise or grain into your images.

Suggested ISO Settings

It is recommended to stay away from the ISO settings 125, 250, 500, and 1000. The preferred ISO settings to use are 160, 320, 640, 1250, 1600, and 2500. It is advised against going over 1600 in order to avoid unwanted noise.

ISO AND GRAIN

This color chart has been shot with the same aperture and shutter speed, but with varying ISO speeds. Note the difference in noise/grain as the ISO gets higher.

Getting the Best Results

Lighting & Audio

Basic Tools

Shooting Video

Post-production

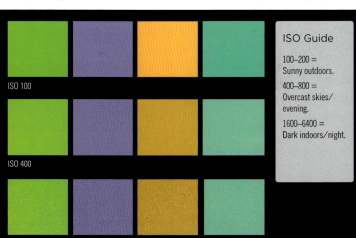

ISO 100

ISO 400

ISO 800

ISO Guide

100–200 = Sunny outdoors.

400–800 = Overcast skies/ evening.

1600–6400 = Dark indoors/night.

Custom White Balance

While you can't always rely on your camera's auto white balance to render the correct interpretation of true white, by manually dialing in a custom white balance you give yourself more control over the color, and allow yourself to manually ensure that the correct color is represented.

It is vital to make sure that you set your custom white balance while you are in the light setup that you will be using when shooting your footage. Selecting your custom white-balance setting, take a picture of a white balance card (or an object as true to white as possible). Fill the entire frame and be sure to focus in on the object. Then, select custom white balance and the image to be used as your reference. Finally, be sure to select custom white balance on your LCD panel and check the accuracy of your custom setting. Also note that some cameras have the ability to perform a white balance shift which will further fine-tune any color inaccuracies.

18% Gray Card
The purpose of an 18% gray card is to help the camera to determine the correct color value so that it properly translates the colors in your exposures as true to the eye as possible. To achieve a consistent exposure and color, the use of a gray card is recommended. Shoot an image of your neutral card under the same lighting conditions that you will be filming in, filling as much of the frame as possible. Then use this image as the basis for your white balance.

White Balance

Correct White-balance Setting
Under mixed light conditions the camera will either under- or overexpose colors and they won't come out as true to what the human eye sees. With an 18% gray card, the reflected light that can be incorrectly read with auto white balance is taken into consideration and correctly interpreted.

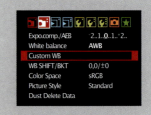

White Balance Correction
Within your camera's settings, you can correct the white balance that has been set. This will produce the same effects that a color temperature conversion or color compensation filter will. You can adjust this setting in your White Balance Shift/BKT menu. A matrix with four points will allow you to shift between blue, amber, magenta, and green.

Light Meter
A light meter measures the amount of light present in an environment. Although your camera has a built-in light meter, you may not always achieve a 100% accurate

Custom White Balance
When working in a mixed light environment it's vital to manually dial in your white balance through the camera's menu.

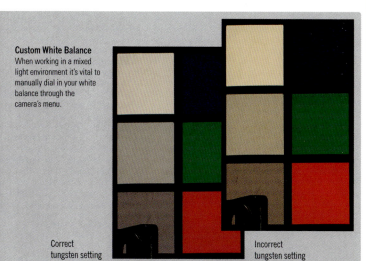

Correct
tungsten setting

Incorrect
tungsten setting

reading of light with it. A handheld light meter will ensure a precise measure of the light falling onto various parts of the subject. There are a variety of light meters available, from the uber expensive to 99-cent apps that you can download to your phone. Depending on the level of accuracy your workflow requires, there are plenty of options out there for you to choose from.

Handheld light meter

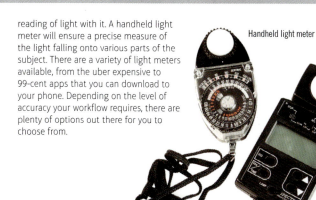

GETTING THE BEST RESULTS

In this section we'll be exploring how to set up your camera to record video. This is absolutely integral to getting the best results possible. We're going to use Canon's EOS 5D Mark II as our DSLR model—Canon set the industry shooting standard with the release of the 5D Mark II and many of its basic camera settings can be mimicked by other models.

Though DSLRs are fantastic tools for recording video, there are a few pitfalls associated with using them for filmmaking. Perhaps the most obvious is that the compact flash and SDHC cards that your DSLR records to are FAT32 file systems.

A FAT32 file system has a file limitation of only being able to "see" a single file of up to 4GB. The video is recorded at such high quality on a DSLR that only 4GB, or 12 minutes, can be recorded at a time on a compact flash or SDHC card.

Another limitation of DSLR shooting is that, even if you are recording at a lower quality, you will still have a maximum record time of 29 minutes per video clip.

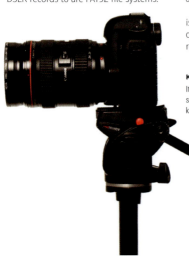

KNOW YOUR CAMERA

It is critical to know the potential pitfalls with DSLR shooting to avoid the need to reshoot footage. Get to know your camera inside and out.

This is due to the fact that some countries have a tax law which states that if a still camera can record videos for longer than 30 minutes each clip, that camera then qualifies as a video camera. This qualification in effect increases the overall price of the camera, so recording time is often limited to 29 minutes.

Another disadvantage of DSLR cameras is that they were not manufactured to produce quality in-camera audio, and have a very poor-quality preamp (electronic sound amplifier that prepares a small electrical signal for further amplification or processing), which diminishes the signal-to-noise ratio (measure of signal strength relative to background noise—or how strong the sound you want to pick up is versus the environmental sound you don't want to record). The onboard microphone does record all of the camera operator handling noise—not ideal. Some DSLR cameras also do not provide you with manual audio control to properly adjust the microphone levels. For this reason, additional audio equipment should always be considered when shooting videos with your DSLR.

The size of the camera itself is another downfall of shooting video on a DSLR. The design of the camera is optimal for still photography, but lacks the ergonomics to be ideally handled as a video camera.

In this section we'll discuss in detail how to improve on these shortcomings using some popular filmmaking tools that are indispensable for professional-looking footage.

CAMERA FEATURES

Camera body

Flash shoe

Interchangeable lenses

Rear display

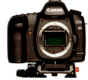
Mode dial

Camera mode display

Memory card slot

External connections

The Basics

GETTING THE BEST RESULTS

17

Lighting & Audio

Basic Tools

Shooting Video

Post-production

Camera Types

DSLR (Digital Single Lens Reflex Camera)

Now that you know the negatives of using a DSLR for moviemaking, what are the benefits of owning one? The single lens reflex camera isn't new technology—this kind of camera has been around for centuries, but only available in analog. Not until the 1990s did the introduction of digital single lens reflex cameras come into play. The birth of the DSLR brought about a few major perks that proved to be a true game changer for photography—and now videography.

The ability to change lenses allows the recorder to fine-tune the camera to fit their visual requirements. Lenses that were once only used on analog SLR cameras have now expanded to also accommodate the digital SLR platform. Digital single lens reflex systems utilize a TTL, or Through The Lens, optical viewfinder. Having the ability to see the picture's composition, as it is, through the actual lens, allows for an accurate focus, which is inarguably beneficial to the shooter's precision in capturing images.

Most DSLR cameras utilize a mechanical mirror system and pentaprism to direct light coming in from the lens to an optical viewfinder located on the back of the camera. When a picture is taken, the mirror flips away, allowing light to hit the sensor and then create an exposure.

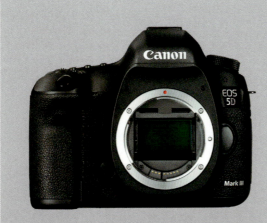

DSLR
The Canon 5D Mark III has a mirrored viewfinder that flips away when shooting.

MILC (Mirrorless Interchangeable Lens Camera)

A recent game-changer in the world of digital cameras has been the introduction of the digital mirrorless camera with an interchangeable lens mount. With smaller and lighter parts, the MILC offers a more compact alternative to the larger DSLRs. The TTL mirror-based viewfinder on the DSLR is replaced with an electronic viewfinder on the MILC, and the sensor, body, and lenses on these cameras are smaller and lighter than those on a DSLR. Also known as Electronic Viewfinder Interchangeable Lens (EVIL) cameras, the first electronic viewfinders had poor resolution and color, along with a lagging display speed. The technology for the MILCs, however, is catching up. Once electronic displays are able to meet true-to-life representation with high resolution, pixel density, and color accuracy, the mirror on a DSLR camera will be obsolete.

The Basics

GETTING THE BEST RESULTS

19

Lighting & Audio

Basic Tools

Shooting Video

Post-production

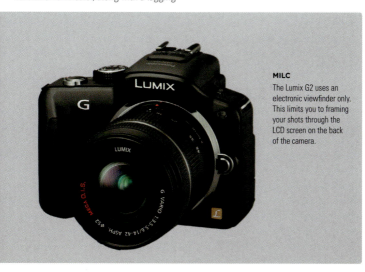

MILC
The Lumix G2 uses an electronic viewfinder only. This limits you to framing your shots through the LCD screen on the back of the camera.

Camera Menu Setup

Before you begin to shoot videos on your DSLR, you must first understand your camera. Knowing the menus and their functions inside out will enable you to fully harness and optimize the power and intelligence of your camera. Your camera is the tool, you are the artist, everything in-between is the expression, so good practice is to master the basics to be certain that quality control starts with you.

Set Your Camera Up to Shoot Video

It is extremely important to understand the camera settings that ultimately determine the image processing. You need to have full creative control over these so your camera isn't forcing exposures and compensations on you. Here's how to set up your camera to shoot video:

1. Begin by powering up your camera
Remove the camera's body cap and the rear cap on the lens. Align the red dot on your lens with the red dot on the lens mount, and turn clockwise to lock into place. Insert a fully charged battery and load the CF card into the card slot, then turn the camera on. Congratulations—you now have a working DSLR in your grasp.

2. Be sure to turn your mode dial to M
You must do this prior to adjusting any of your video settings. This step is an important prerequisite that must happen each time you shoot video, as it enables you to adjust all of your settings manually. If your camera is not set to manual, you will not have the option to choose certain actions within the menus. This will, in turn, affect the look of your video.

3. Disable peripheral illumination correct
This function automatically corrects the light that you see around the perimeter of your lens. You should disable this function so that you have manual control over your images and how they look. Again, you want to avoid surrendering image control to the camera.

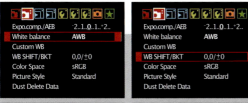

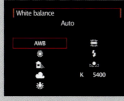

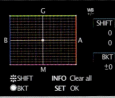

4. Set your white balance in Kelvin.

The Basics

GETTING THE BEST RESULTS

21

Lighting & Audio

Basic Tools

Shooting Video

Post-production

4. Set your White Balance in Kelvin
The Kelvin temperature measures the relative warmth or coolness of white light, and setting this manually, dialing in your white balance according to how you want the image to look is another important aspect of controlling your settings to give the effect you want. Manually dialing in the Kelvin temperature in the white-balance setting gives you the ability to make your shots slightly warmer or cooler depending on your vision. Input this using the main dial, or by using the Quick White Balance button at the top of the camera, near your LCD panel. By holding this down and turning the main dial, you can also dial in your white balance very quickly.

5. Choose your Color Space
This is best set to Adobe RGB if you plan on using your images for commercial and industry uses. sRGB will give you less toned-down image results. The major difference between these two options is that the purpose of the Abobe RGB setting is to generate very flat image results that are more easily edited in post-production. If you don't plan to heavily edit your footage in post-production, sRGB footage will turn out less flat, toned down, and will require less color grading and correcting in post.

6. Picture Style in Neutral
Your Picture Style setting should be set to neutral. If left to its own devices, the camera will shoot in a

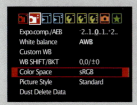

5. Choose your color space.

6. Picture style in neutral.

7. Disable highlight tone priority.

10. Suggested LCD brightness.

compressed format. If you choose one of the built-in picture styles with higher contrast, for example, you could be losing a lot of detail in both the shadows and the highlights. The neutral picture style is a lower contrast image that will retain more of the precious image information, which will allow you to adjust it later on in post-production. In post-production, you can always boost the contrast, sharpness, and saturation—using a neutral setting gives you a blank canvas to work with.

7. Disable Highlight Tone Priority

Highlight Tone Priority will attempt to retain the highlights in your images by automatically underexposing. You should disable this so the camera won't change exposures while you move. The last annoyance you want to deal with is seeing your camera automatically alter your images while you're in the midst of shooting video. Your film's consistency will be lost and your footage will suffer. Save yourself the retake time and disable this feature.

8. Image Jump

Image Jump is a convenient feature to set to 1. This will allow you to jump through your video clips one at a time. If set to increments other than 1, your scroll wheel will take you through your video clips, for example, three or six at a time—whichever number you've set this feature to. To avoid an added step in your workflow, set it so you can always go back to the desired clip one at a time for playback review.

9. Auto Power Off

Auto Power Off should be set to 8 minutes. If you do not allow your camera to power off occasionally, the sensor will overheat. This will introduce a lot of fixed pattern noise, which is to be avoided. If you are shooting on your DSLR for long periods of time, allowing the sensor to rest and cool off is good practice. Allowing the camera to power off will also save on battery, as DSLRs run through battery life very quickly, especially when shooting HD video.

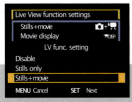

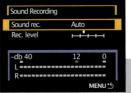

14. Sound recording.

12. Setting the Live View feature.

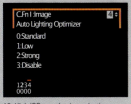

16. High ISO speed noise reduction.

The Basics

GETTING THE BEST RESULTS

23

Lighting & Audio

Basic Tools

Shooting Video

Post production

13. Movie Recording Size
This option will enable you to capture video in a range of different resolutions and frame rates. Which one of these you choose will be determined by your geographical location and desired image size. For optimum resolution select 1920×1080, and for more on resolutions and frame rates see page 10 for frame rates, and page 25 for resolution.

14. Sound recording
If you plan on using the onboard microphone, the auto setting works well, but by plugging an external microphone directly into the camera, you can get optimal sound quality by adjusting the levels manually. However, even if you are using an external microphone with your camera, the audio captured will not be nearly as good as the sound that can be achieved by using an external preamplifier (a piece of equipment that improves the signal coming in from the microphone and reduces the noise), or a separate audio recorder.

15. Exposure ISO Expansion
You'll want to set the Exposure ISO Expansion setting to increments of 1/3 of a stop, or 3. This has been proven to be the optimal setting for video, as in this mode you have more increments to manually increase the ISO range of your camera.

16. High ISO Speed Noise Reduction
Disable this feature. You should be aware of how much noise is being introduced, as this feature can make your images soft as it attempts to blend the grain that can occur when shooting at a high ISO.

10. Suggested LCD Brightness
The LCD brightness is best manually set to 4 or 5. This will give you an image easily viewed by eye without draining your battery and over- or underexposing the true colors of your image.

11. Keep your Sensor Cleaning to Auto
Sensor Cleaning is best set to Auto. When you allow your camera to clean the sensor automatically, you're ensuring that for each use, any potential debris or dust that falls onto the sensor is shaken off, as small vibrations shake the sensor clean. This is desirable, as any obstructions on your sensor will translate onto your exposures and could potentially ruin your footage.

12. You can't record video unless you set the Live View feature
Live View is a function that must be set correctly in order to enable the camera to record video. In the Live View function, set your camera to Stills+Movie. If you don't complete this step, you will not have the ability to shoot video on your camera.

Information Display

Your information display is a crucial tool for shooting good video, as it relays the selected camera settings to you. Ensure that you have the following menus displayed at all times to avoid exposure mistakes while shooting—having to reshoot because of a simple oversight can be devastating.

Live Histogram
The live histogram can optionally be displayed in the rear screen to allow you to make adjustments to your exposure and ensure it is correct. The purpose of the histogram is to show you on a graph where the areas of brightness and darkness in your image fall. You can also use the histogram to check RGB color saturation and gradation.

Display
Having the ability to shoot video in high definition is one of the major perks that comes with owning a DSLR. HD has a much higher resolution of pixels than standard definition. The most common resolutions you will see are 1280×720 or 1920×1080, where the horizontal by vertical pixels are represented by numbers of lines in a picture. The more lines, the clearer the picture on-screen will appear.

Often, we see resolution represented with an "i" or a "p" at the end, for example, 720p, 1080p, or 1080i. The i stands for interlace and the p stands for progressive scanning. Progressive scanning means that each line on the screen is refreshed in sequence. Interlaced is refreshed to the screen twice every

LCD Display

Brightness Display
Shows both trends in exposure levels and overall gradations.

RGB Display
Shows color saturation and gradation.

Within the brightness display, crushed blacks and overblown highlights are represented when the graph is skewed too far to the right or left. The other areas show gradations.

In the RGB color display screen, the histogram will interpret the same information for darkness and brightness within the red, green, and blue tones of the exposure for saturation and gradation.

The built-in light meter on a DSLR will not always meter correctly for proper exposure. Different variables such as available light levels and light- or dark-colored subjects can alter the metering of the correct exposure. Using the live histogram is a practice that will help you to check for correct exposure of your shots.

On-screen LCD histogram

frame, first the even pixel lines, then the odd pixel lines.

A recent development in high-resolution video has been the introduction of 4K television panels. While full HD televisions have a resolution of 1920×1080 pixels, 4K panels are much sharper and have an increased resolution of 3840×2160. With Canon developing a full-frame DSLR capable of shooting 4K video at 24P with APS-H cropping, cameras capable of shooting in 4K will become increasingly available in the marketplace.

Resolution

Progressive Resolution
Progressive scanning means that each line on the screen is refreshed in sequence.

Interlace Resolution
Interlaced is refreshed to the screen twice every frame, first the even pixel lines and then the odd.

Aspect Ratio

Aspect ratio refers to the ratio of the width of an image to its height. Expressed as two numbers separated by a colon, aspect ratio determines the dimensions of a display resolution. For example, a resolution of 800×600 has an aspect ratio of 4:3 (almost square); 1920×1080 has an aspect ration of 16:9 (rectangular).

16:9 Aspect Ratio Sizes

Best	Better	Good
1280 × 720	1152 × 648	1216 × 684
1024 × 576	896 × 504	1088 × 612
768 × 432	640 × 360	960 × 540
512 × 288	384 × 216	832 × 468
256 × 144	128 × 72	704 × 396
		576 × 324
		448 × 252
		320 × 180
		192 × 108

4:3 Aspect Ratio Sizes

Best	Better	Good
640 × 480	608 × 456	624 × 468
576 × 432	544 × 408	592 × 444
512 × 384	480 × 360	560 × 420
448 × 336	416 × 312	528 × 396
384 × 288	352 × 264	496 × 372
320 × 240	288 × 216	464 × 348
256 × 192	224 × 168	432 × 324
192 × 144	160 × 120	400 × 300
128 × 96		368 × 276
		336 × 252
		304 × 228
		272 × 204
		240 × 180
		208 × 156
		176 × 132
		144 × 108
		112 × 84

The Basics

GETTING THE BEST RESULTS

25

Lighting & Audio

Basic Tools

Shooting Video

Post-production

Lenses

Lenses are an investment that will always stand the test of time. I now own my father's old Canon and Nikon lenses that he acquired back in the 1960s and 1970s. These lenses are still as sharp and magnificent as they were when he bought them. A great lens never goes out of style or becomes outdated to the point of being rendered useless. The camera body is crucial, yes, but the lenses will exceed the life of your camera if they're well taken care of. High quality glass comes at a price for a good reason. Let's get to know the basics before you make your purchases. Some focal lengths may be a better fit for your workflow and taste. Knowing how to choose from what is on the market is the key to fool-proofing your buying.

Focal Length

The focal length of a lens will determine its angle of view. A shorter focal length will have the lens positioned closer to the sensor. A longer focal length requires the lens to be further away from the sensor. For example, when you zoom in on a subject and your zoom lens extends, your focal length is longer.

Normal (50–55mm) A lens that covers a normal focal length will render the same depth perception as seen by the human eye. Parallel lines appear wider apart when closer, and respectively, will seem closer together when they're further away. If you were standing at the end of a long and straight road, the road would appear to be more narrow at the furthest point your eyes can see, or at the vanishing point. The road would appear wider at the point where you were standing. A normal lens will stay true to this depth perception.

Wide (16–35mm) A wide-angle lens has a field of view that is wider than a normal lens. Where a normal lens only allows you to see at about 127°, a wide-angle lens will give you 170° of viewing. The greater field of view that wide-angle lenses offer can make objects appear to be spaced further apart than they really are. Wide-angle lenses can be used to exaggerate relative size and depth. In enclosed spaces with limited room, a wide-angle lens can be used to capture more of the interior. When you cannot pull the lens back far enough to get the shot you want in an enclosed space, a wide-angle lens is your best ally.

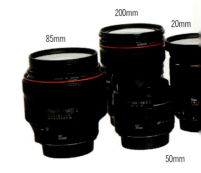

200mm

20mm

85mm

50mm

Telephoto (80–500mm) With a telephoto lens, magnification is greatly increased and a smaller field of view is introduced, making the perceived distance between objects more compressed. When shooting video, using a telephoto lens can be tricky because the field of view is so narrow. This makes any slight movement incredibly noticeable to the viewer. Image stabilization is highly recommended for these types of lenses.

LENS KIT FOR VIDEO

DSLR video shooting has opened the world of lenses up to many filmmakers. There are hundreds of choices, and purchasing decisions are based on the types of videos you are making. Zooms are great for flexibility, but primes deliver sharper images.

Prime and Zoom

A prime lens has a fixed focal length, whereas a zoom lens has a variable focal length. Primes come in all lengths, but zooms will give you a range of different focal lengths all in one single lens. It is often argued that prime lenses offer better performance, since they are crafted optimally for one specific focal length. Zooms will give you more flexibility as they offer multiple focal lengths in a single lens, however, they have a smaller maximum aperture. Lenses capable of achieving very wide aperture values are considered to be "fast" lenses because they can let in more light. Zoom lenses generally aren't as fast as primes. Auto Focus lenses for still photography have a focus system that is very different than those found in true cinema lenses. The movement of the focus ring on an Auto Focus lens normally travels in a much shorter distance, making it harder to achieve smooth focus pulls. Cinema lenses do not have any auto focus features and are designed to have smooth, longer manual focusing movements.

The Basics

GETTING THE BEST RESULTS

27

Lighting & Audio

Basic Tools

Shooting Video

Post-production

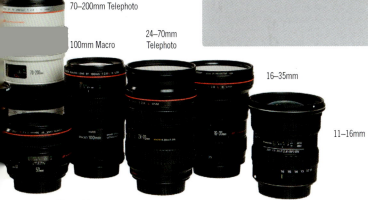

70–200mm Telephoto

100mm Macro

24–70mm Telephoto

16–35mm

11–16mm

50mm wide

Crop Factor

Crop factor refers to the ratio of the dimensions of the camera's imaging area using the 35mm film standard dimension as a comparison reference. In other words, it refers to the magnification effect of a cropped DSLR sensor against a full-frame sensor. Digital camera sensors are generally smaller than 35mm film. When a photo is made with the same lens and the image sensor is smaller, a smaller portion of the image will be shown, hence the term crop factor.

This ratio is also commonly referred to as FLM (focal length multiplier), since multiplying a lens' focal length by its crop factor or FLM gives the focal length of a lens that would yield the same field of view if used on the reference format.

Full Frame A full-frame camera is one where the frame is the same size as 35mm film and no crop factor is introduced, for example, Canon's 5D Mark II.

APS-C Advanced Photo System type-C is an image sensor format approximately

CROP FACTOR

Understanding what crop factor your camera has will enable you to select the most appropriate lens for the shot.

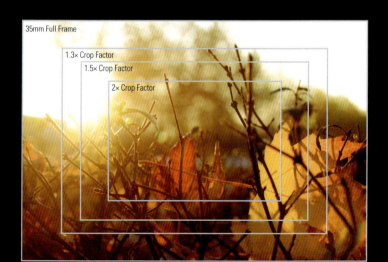

35mm Full Frame

1.3× Crop Factor

1.5× Crop Factor

2× Crop Factor

The Basics

GETTING THE
BEST RESULTS

29

Lighting & Audio

Basic Tools

Shooting Video

Post production

equivalent in size to the classic negatives found in Advanced Photo Systems that were 25.1×16.7mm and had an aspect ratio of 3:2. Lenses specifically made for APS-C cameras use a smaller area than full-frame lenses to capture the image and in effect introduce a crop factor.

Micro Four Thirds The sensor size and format is what gives the Micro Four Thirds system its name. With an aspect ratio of 4:3, the sensor size for this system is 18×13.5mm, and has an imaging area of 17.3×13mm. The image thus has a diagonal length of 21.6mm. This is roughly half the imaging size of 35mm film or a full frame.

IMAGE STABILIZATION
When shooting video with IS switched on, ensure you aren't capturing any noise from the motor on your sound recording.

Image Stabilization

Image stabilization or "IS" technology reduces the blurring that occurs while the camera is moved during an exposure. IS is designed to compensate for the panning and tilting movements of a shaky hand. When using image-stabilized lenses, the sound of the IS motor can sometimes be picked up by the in-camera microphone.

Filters

Filters not only protect the glass in your lens, but can also change the intensity or color of light entering into the lens, depending on what type of filter you purchase. Filters come in different sizes and types, so if you're planning to purchase a filter to fit directly to your lens, be sure to choose the correct diameter to thread onto the lens. If the size of the filter thread is not written on the lens itself, you can usually find this information on the back of the lens cap.

Neutral Density

Neutral Density (ND) filters are designed to allow you to keep your shutter open for an extended period of time in bright settings, and avoid overexposure by cutting the amount of light let into your lens and exposed to the sensor. You can adjust your exposure according to the density of your filter. Some are darker or more dense, while others are lighter and have less density. ND filters come in different stops. You can also stack these to create your own density to dial in the exposure you desire. The only caution you should exercise in using this technique is that stacking ND filters can cause a color cast and/or vignetting.

An ND filter is an essential tool for controlling ambient light. This will allow you to dial in your shutter and aperture settings as desired.

Variable Neutral Density

A variable neutral density filter allows you to have the versatility of varying density filters all in one. By rotating the filter clockwise or counterclockwise, you can change the density, blocking more or less light.

Filter Types

COLOR FILTERS
Color filters are used to give your image a color cast. This type of filter can be used to correct for color casts in the available lighting or to add an intentional stylized look.

ULTRA VIOLET FILTER
A UV (ultraviolet) filter protects the front element of your lens, while also blocking out UV rays. The UV filter won't affect your images, as it is more about protection against scratches and everyday use. After all, it is much cheaper to replace a scratched UV filter than it is to replace your lens.

NEUTRAL DENSITY FILTER
An ND filter reduces or modifies the intensity of all wavelengths or colors of light equally, giving no changes in color.

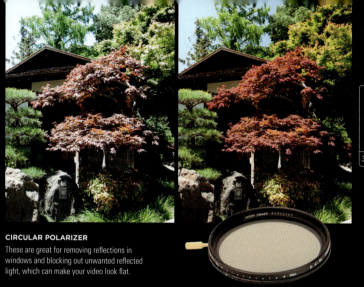

The Basics

GETTING THE BEST RESULTS

31

Lighting & Audio

Basic Tools

Shooting Video

Post-production

CIRCULAR POLARIZER

These are great for removing reflections in windows and blocking out unwanted reflected light, which can make your video look flat.

Circular Polarizer

When shooting outdoors, light can be reflected by just about anything, causing a glare on surfaces. For example, light reflections on a windshield, water, plants, or even a hazy sky can affect your shot. A polarizing filter cuts out the reflected light, allowing the true colors in your image to come through, while saturation and contrast is boosted.

In the images above, the same shutter, aperture, and ISO settings were used in both examples. The difference in image quality was seen when the polarizer was turned to block the stray reflections of light. The "blown out" highlights in the leftmost image are not caused by poor shutter or poor aperture settings, but by very bright reflections of light. As the camera is not able to capture the details in this image, unfortunately the information is lost, and there is no way to correct this in post-production. For video capture, where the image is captured in real time a polarizer is a very important filter to use outdoors in bright daylight.

A circular polarizing filter can be turned clockwise or counterclockwise to cuts out reflected light. As you turn the filter, you should be able to see the results immediately.

Framing

Understanding how to properly frame your shots is at the core of photography and cinema fundamentals. Framing is the way you draw attention to your subject by using the space and environment within the shot to create an overall aesthetic appeal. Each scene in a movie tells a story and within the story, each frame is composed of thoughtful lines, points, and spaces designed to purposefully draw attention to the subject. Here are a few of the key laws on framing—you are not required to slavishly abide by them, so long as you fully understand them, and why they work. Feel free to experiment!

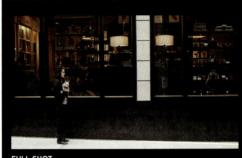

FULL SHOT

Full

When capturing a full shot, the entire subject will be in the frame. Always remember to keep the whole body (including the feet of your subject) in a full shot. As a fundamental guideline, you should never cut a shot of a person at the joints, such as at the knees, elbows, or hands. This type of framing looks unnatural and can turn out to be very unflattering for the subject. Oftentimes, a full shot is used as an establishing shot. The full shot sets the scene, giving exposition to the story, often revealing the time of day, season, and geographical position.

A full shot can also help the audience gain insight into who the character is by showing clothing, body language, interaction with people, and other unique idiosyncrasies. Full shots require sufficient lighting of the whole person and this will require further attention because there are more elements to consider. Keep this factor in mind when shooting full shots.

An establishing shot of some sort is almost always the first shot of any movie to provide the audience with a context for the following scenes. Where is the location? When is this taking place? Who are the characters? What are they doing? Your establishing shot relays this information to the viewer and gives meaning to the storyline. Even a documentary or news report will usually open with an establishing shot showing "who, what, where, when, and why." There is no true formula to shooting an establishing shot, so you can be creative with this aspect of your video.

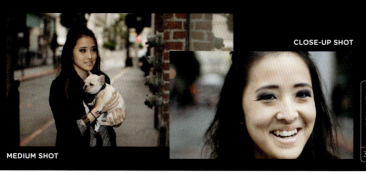

CLOSE-UP SHOT

MEDIUM SHOT

The Basics

YOUR CAMERA & SETTINGS

33

Lighting & Audio

Basic Tools

Shooting Video

Post-production

Medium-full and Medium

The medium-full shot is more intimate than a full shot, orientating the audience as to the subject's position in the scene, and identifying their relative position to other key elements of the scene. This type of frame will typically cut your subject somewhere between the thighs and waist.

A medium shot will normally show a character from the waist up, and should show the face of the subject clearly enough to depict the facial expressions. Medium shots are a great opportunity to bring dynamic camera movements into your video. A slider or jib can turn an average medium shot into a moving experience. Shots like these are easy to achieve with the proper equipment and will elevate your video to a professional level. I further discuss what equipment you will need for these types of shots in the gear section of the book.

Close and Close-up

The close and close-up shot are relative to what the story is pointing to and capture the emotion and reaction of your subject. Normally, an establishing shot comes before or after the close and close-up shots within a sequence. If you skip the establishing shot altogether and only show the close shot of a subject, no context is provided and the storyline as clear. Within a close shot, facial features and expressions are emphasized. A close shot will be somewhere around the breast area and above, whereas a close-up is from the neck up with a tight crop on the head. A more detailed and telling story is conveyed and insight into the main subject is drawn out on a deeper level.

Extreme Close-up

An extreme close-up might cut the subject off around the forehead and chin. Anything around a frame this tight or closer will be considered an extreme close-up. This type of shot is intended to reveal the most intimate features on the face and can really give the viewer insight into the emotions and characteristics of the subject.

Composition

In video terms, composition refers to the placement and arrangement of visual elements within a shot. Lines, points of focus, and space are a few elements you should pay close attention to when composing your shot. Directors compose to tell a story, but also to create beautiful aesthetics and strong compositions to play on the emotions and curiosity of the viewer.

This is the fundamental method behind good composition. Once you begin to practice the simple rules I lay out below, the way you see and set up your shots will change. Each individual has their own perspective, and bending the rules is solely up to you. Experimenting with composition is great, but it helps to know the common composition understandings that have been in practice for centuries.

Headroom and Lead Room

Piggybacking on the rule of thirds, leaving a subject headroom gives balance to the shot composition, while too much headroom will stunt your subjects, losing them in the shot. For optimum headroom, place your subject's eyes near the top third of the frame. When shooting a subject, lead room is the amount of space in front of, or in the direction that the subject is moving. Without lead room, a sense of direction and purpose isn't conveyed and the shot can relay a sense of confusion instead of clear storytelling.

Rule of Thirds

This rule ensures your images are pleasing to the eye, effectively balancing the elements of the shot within the frame. Dividing the frame into thirds—both horizontally and vertically—composes the shot according to the rule of thirds. When a subject is placed in the meeting points of two of these lines, the shot translates as dynamic and more pleasing to the viewer. Why does the rule of thirds work? The 2:1 ratio is a mathematical equation that has been used for centuries by visual artists and has been proven time and again to work. You can apply the rule to almost any environment, and indeed, it should be considered in all your shots to keep them aesthetically appealing and well-balanced.

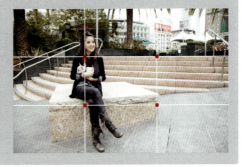

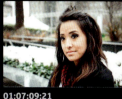

01:00:05:11 01:06:03:10 01:07:09:21

EYELINE

01:00:09:01 01:05:05:24 01:02:02:01

BACKGROUND

01:01:03:10 01:02:01:20 · 02:00:06:21

The Basics

GETTING THE
BEST RESULTS

35

Lighting & Audio

Basic Tools

Shooting Video

Post-production

Eyeline

The viewer wants to see what the subject is seeing. The eyeline match begins with the character looking at something or someone on- or off-screen. The cut to what that person or object is looking at is then revealed. If I'm looking down, the cut should match my eyeline for continuity. If two people are talking, the eyeline should match the same height and direction.

Background

In order to keep your subject as the main focus of the shots, you must make sure that the background you're shooting against isn't distracting. If it overpowers the main focus, the viewer can't follow the story easily. Blurring out the background with a shallow depth of field or selecting a plain environment are methods of keeping the attention on the intended subject.

LIGHTING & AUDIO

Lighting and audio are two elements to video that simply cannot be ignored. The available light must be deliberately manipulated to some degree when shooting video, because as we've seen already, your camera won't pick up the same lighting seen by the eye. As for recording audio, for quality sound, you'll need an external microphone, and this is one of the reasons why professional productions have a person dedicated to audio recording—the choice of which external microphone to use can have a huge impact on the quality of your recording.

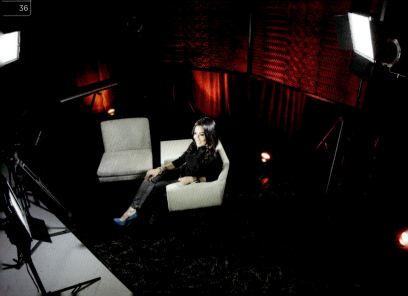

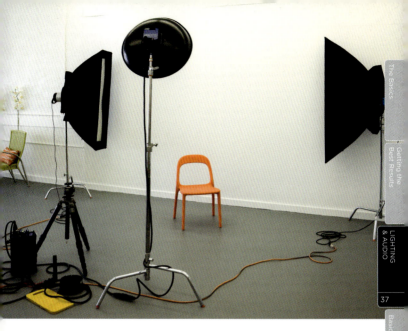

The Basics

Getting the
Best Results

LIGHTING
& AUDIO

37

Basic Tools

Shooting Video

Post-production

Though there are no hard and fast rules
on how to light a set—and everyone has
their own approach to how much, how
little, and where to use it—there are
certain standard lighting techniques used
by the movie industry that have proven to
be fool-proof in achieving certain aesthetic
looks. We'll take a look at a few of them
throughout this chapter, as well as lighting
tips, tricks, and essential tools.

As with everything else, the logic
behind and foundation of lighting
must first be established before you can
begin to play with technique. Once you
understand how basic lighting is achieved,
you can then go on to creating and
shaping your setups to match your
own taste.

As for recording sound, while there
is no one microphone that is perfect in
all situations, there are three types that
are used most often: cardioid, lavalier,
and shotgun. We'll explore the different
options available to video shooters who
use cameras, and take you through how
capturing audio works.

FLATTERING LIGHT

Interviewees and
presenters in a studio
setting are lit flatteringly,
with soft light.

STUDIO SETUP

Though you can make-do
with a simple lighting
setup, you'll need to
invest in a couple of lights
to get a professional
studio effect.

Hard & Soft Light

To explain the difference between hard and soft light I'll use LED panels and softboxes as example light sources of each type.

Not all LED lights will give you the same look. Depending on the size of the light panel, and whether or not it comes with a dial to change its intensity, you will experience slightly different results. The one consistent factor, however, is that the light will be harsh, highly contrasted, and directional. It will cast prominent shadows and will not cover the surface of objects as evenly as a softbox. A softbox will give off soft or diffused light. This is due to the diffusion of light from the softbox's diffuser panel. As the light thrown by the LED lamp is directional you will get only a small amount of gradation or "wrapround" of light on your subject due to the absence of diffusion. This is opposed to the diffused light thrown by the softbox, which will be more scattered and have a broader throw pattern.

Similarly, not all softboxes will give you the same look. In short, the way a softbox works is that the light source (in our example a CFL bulb) bounces the light around in the box, diffusing the light before throwing it onto the subject. Diffused light covers a broader surface area than directional light, causing the light to wrap around the subject, creating softer shadows. What's great about a softbox is that, depending on the size of the box and panel, the same light inside it can be thrown to cover a larger surface. With a diffused light source, you'll see that

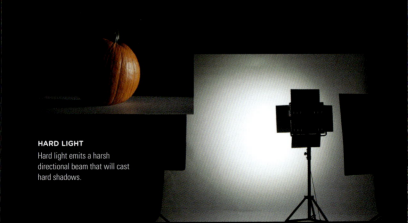

HARD LIGHT
Hard light emits a harsh directional beam that will cast hard shadows.

the gradient of the light drop off is much more even.

Flood Lights
Hard or Directional Light

Hard or directional light is a light source with no diffusion introduced. Directional lights are so called because they point the light throw in a specific direction. These types of lights are harsher than diffused light and are usually directed with barn doors and/or a spotlight dial.

Placing a grid or egg crate over a light will help to direct the light, broadening the throw. With a diffused light the throw will become more directional, and you will experience less light spill and a tighter light with less wraparound.

Soft or Diffused Light

Soft or diffused light is scattered, and therefore softer than directional light. Diffused light creates a more even gradation of light onto the subject and doesn't have the glare that direct light gives off. It is typically more flattering on facial features than direct, hard light. Soft light will not create the harsh tonal contrast that hard light will.

Ambient Light

Ambient or available light is the light already present in an environment, not including any source of light deliberately introduced by the videographer. Ambient light is the condition of the environment as it is naturally lit.

The Basics

Getting the Best Results

LIGHTING & AUDIO

39

Basic Tools

Shooting Video

Post-production

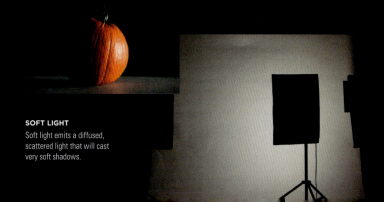

SOFT LIGHT
Soft light emits a diffused, scattered light that will cast very soft shadows.

Types of Light Sources

Open-face Hot Light

Open-face hot lights have a tungsten filament and become very hot to the touch, so should always be handled with gloves. These lights typically have a Flood mode and Spot mode. Flood lighting is broad and can be used as ambient light to light large spaces. Spot lighting will focus in on the subject for a more directional look. As before, to direct the light in a more focused manner barn doors can be used to hone in on the subject.

Softbox

A softbox is a versatile piece of kit that can transform an open-face hard light into a lovely soft light. Covering an open-face light with a softbox will diffuse it and give it a wider footprint on the set or the subject. When using a softbox the light has a shorter throw, or reach, than an open-faced light, so you will need to move the light closer to your subject since it is no longer as strong. An umbrella also makes a good diffuser to soften the light.

Open-face Cool Light

Open-face cool lights are fluorescent lights with lamps that do not give off the extreme heat of hot lights, and they also use less energy. Fluorescent lights manufactured for video production are color balanced so they don't give off the green "spikes" or flicker that is often associated with capturing fluorescent lighting on camera. These lights are also

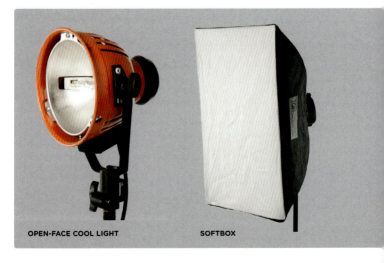

OPEN-FACE COOL LIGHT SOFTBOX

softer than spotlights and give a more even spread of light.

Barn Doors When you want to direct the light and focus it in on a subject, barn doors allow you to do that without having to change the luminosity of the light.

Flag A flag prevents light spill from illuminating unwanted areas, masking part of the light source. Flags direct the light, keeping it contained to only the area that is intended to be lit.

Black Foil

Black foil is used to mute light, and can replace a flag or be used to wrap objects that are producing unwanted glare. The foil is pliable and therefore can be shaped into a lens hood, a rounded French flag, or really any shape you can imagine. If there is a need to cut light, black foil is a quick—and inexpensive—solution.

The Basics

Getting the Best Results

LIGHTING & AUDIO

41

Basic Tools

Shooting Video

Post-production

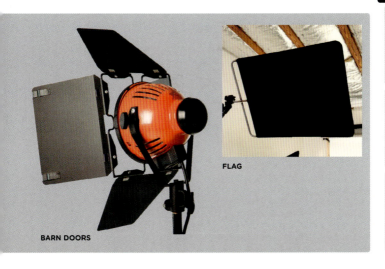

FLAG

BARN DOORS

Light Emission

The power of an artificial light is measured in watts. The luminosity or brightness varies according to the wattage.

CFL

CFLs (compact fluorescent lamps or lights), are the energy-efficient alternative to incandescent lamps. As they only use around a third of the power that incandescent lights use, have a longer life-span, and generate significantly less heat, CFLs have risen in popularity in recent years. The softer white light that CFLs give off is perfect for softboxes.

Softboxes that use compact fluorescent lightbulb fixtures are popular inclusions in video lighting kits for studio setups. One problem that some experience when shooting video with CFL bulbs is detecting a flicker to their video. This occurs when the ballast produces enough electricity to energize the gas inside the bulb. While not all CFL bulbs produce a flicker strong enough to be captured, keep in mind that there is usually a period of time needed for common CFLs to warm up before they reach their full luminosity. This flicker is very slight when compared to the magnetically ballasted long tube fluorescent bulbs. These give a very noticeable flicker that will definitely be picked up by the camera if you try to shoot video with this lighting alone.

So is there a solution? Yes, in the form of the flicker-free CFL bulb. Companies like Alzo manufacture video-friendly CFL bulbs, such as their Video-Lux line of spiral CFL bulbs. These are not only affordable, but

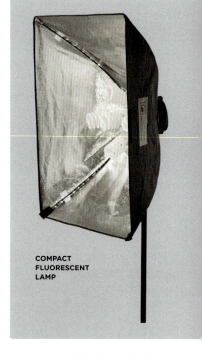

COMPACT FLUORESCENT LAMP

also completely flicker-free. Bulbs like the Video-Lux are specifically designed to solve the flicker problem that CFL lighting is often associated with. The bottom line for flicker-free bulbs is this: no matter what shutter speed you use, there will be no light flicker introduced to your video. There are also tungsten options available, depending on the manufacturer.

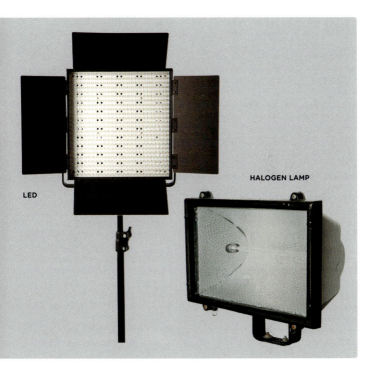

HALOGEN LAMP

LED

The Basics

Getting the Best Results

LIGHTING & AUDIO

43

Basic Tools

Shooting Video

Post-production

LED

LED (Light Emitting Diodes) lights are rapidly becoming the popular solution to lighting a video production. LEDs are lightweight, compact, cool, and draw far less energy than halogen lights. LEDs can be run off of battery power for extended periods of time due to their low energy consumption. These low-power consumption units are a great choice for lighting a scene on location.

Halogen

Halogen lamps (lights) are referred to as "hot" lamps as they require a lot of energy and give off a lot of heat. These type of lights are considered closer to tungsten in color temperature. The advantage of using halogen lighting is that it gives off a high luminosity, and the disadvantage is the high levels of heat and energy it produces. Available at most hardware stores, these lights are low-cost, high-output lighting solutions.

Color Correcting & Styling Gels

The color temperature of a light source can be altered or corrected by the use of filters or color gels. If there is a mixture of colors being emitted from your light sources, it's necessary to balance the color temperatures in order to get a correct, natural white balance. By covering a light with color gels, you can accurately light your scene and get a true white balance. You can also stylize your scene by using color gels to throw a certain color cast on your set, adding artistic impact.

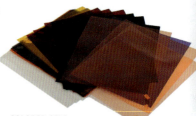

COLORED GELS
Also known as theatrical gels, these can add atmosphere to your lighting setups.

Color Temperature Blue
CTB (color temperature blue) gels come in varying strengths and are used to cool warm lights that have an orange hue. The matching of tungsten lights with a daylight source or to sunlight coming through a window is done with CTB gels. CTBs can also mimic the look of nighttime or add intensity, giving an even cooler temperature to an already cool light.

Color Temperature Orange
CTO (color temperature orange) gels are used to warm lights or warm the color temperature of a light with a blue hue. Conversely, these gels can also be used in conjunction with a cool light source to match tungsten ambient light.

Plus & Minus Green
Artificial lighting that is not intentionally manufactured for video purposes is not correctly color balanced, and actually gives off a greenish color cast. When shooting under artificial lighting, using a minus

green gel will neutralize the green color cast introduced by the fluorescent light and all of its annoying green glory. By no means ever have a person's face lit with a sickly green color caused by fluorescent light. Always remember to utilize your minus green gel to correct this.

Stylizing Gels
These heat-resistant sheets of colorful plastic can appear to be festive plastic wrap at first glance. But take a closer look and you'll see all of the versatility the gel gives you. The addition of a specific color cast to a scene can add drama or even represent a specific time of day.

Diffusion Gels or Filters
When hard light needs to be softened, diffusion filters, gels, or materials present another alternative to softboxes. Diffusion filter and gel options come in a wide range of intensities and mediums.

Scrim

Scrims are metal screens mounted in a frame and placed in front of a light source to reduce the intensity of the light. A scrim will cut down light by a number of stops. Scrims come in different intensities and types—a half scrim, for example, will cut out only half the light of a full one.

C47

The C47, also known as a regular old wooden clothes pin, is beloved by all video production junkies. The C47 is typically what fastens gels and diffusion filters onto barn doors, and crucially, they won't melt or leave any evidence of their presence behind.

Background Light

A background light is needed to illuminate the backdrop and eliminate any shadows cast by any foreground objects or due to low light. Properly lighting the background is very important, both so it can be clearly seen within the shot, and to avoid the subject melting into the background.

Special Light

A special light is dedicated specifically to light a single object. This is usually a small pool of light that is intended to bring attention to something specific by highlighting it with the light.

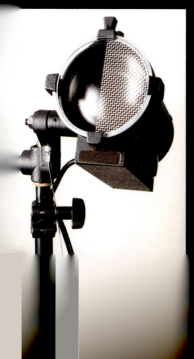

Three-point/Four-point Lighting

Three-point lighting is a standard method used in video production. By using three separately positioned lights—the key, fill, and backlight—the photographer can light the subject however they want, while also controlling the shading and shadows produced by direct lighting.

Key
The key light is the main light on your subject, and should be positioned so that it illuminates as much of the subject from the front as possible. Due to the fact that there will be too much shadow on the opposite side of the subject to the key light, a fill light must be introduced to even out the subject's features. For the fill light, you can use either a powered light or a reflector. Both of these will work, so long as the subject is properly lit.

Fill
The fill light fills in the darker, shadowed areas that the key light cannot reach. The shadows created by the direct key light are illuminated and filled in, controlling contrast and correcting shadows. Utilizing a diffused light as the fill light creates a soft and even effect—a good choice as the purpose of a fill is to assist the key light in evenly lighting the subject. A fill light will help to avoid an unintended chiaroscuro effect—a stylized and highly contrasted look of light and dark features. This can have a very harsh and unflattering effect on a person's face, so keep an eye on your setup when lighting people.

Backlight
Also referred to as a rim, hair, or shoulder light, the purpose of a backlight is to separate the subject from the background.

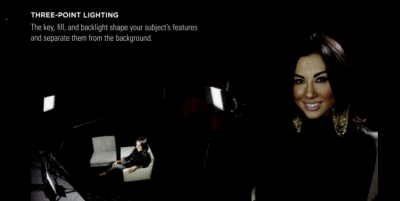

THREE-POINT LIGHTING
The key, fill, and backlight shape your subject's features and separate them from the background.

The rim light adds dimension and contrast to the shot and serves to help focus the viewer's attention on the subject by highlighting their outline. The backlight is positioned behind the focal point and creates a rim of light subtly or sharply outlining the intended subject. The highlighted outline is what enhances the separation between the background and foreground. The backlight should be positioned back three-quarters either on the left or right of the subject.

Note the position of your backlight and play around with it. Is the light above or below the eyeline? This can affect the mood and overall look of the image. The treatment of your rim light can vary in orientation, color, and intensity.

Kicker

A kick or kicker light is very similar to a backlight in that it is positioned behind the subject. However, instead of only creating a very fine outline around the subject, as the backlight does, the kick light actually casts an intentional shadow onto the visible side of the subject.

Four-point Lighting

Four-point lighting consists of exactly the same setup as three-point lighting, with an additional fourth light dedicated to illuminating the background.

The Basics

Getting the Best Results

LIGHTING & AUDIO

47

Basic Tools

Shooting Video

Post-production

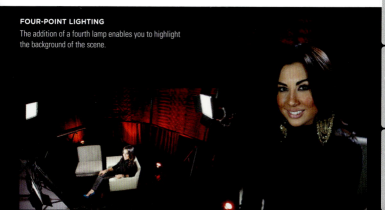

FOUR-POINT LIGHTING
The addition of a fourth lamp enables you to highlight the background of the scene.

Catchlights

Catchlights are a reflection of a light source in the eye of your subject. They come in all shapes, sizes, and varieties. Often they're created with single lights dedicated for use as a catchlight, for example, popular catchlight options include softboxes or ring lights. Used in both still and motion-picture photography, the introduction of this simple light can add vitality and life to your subject. Without catchlights, eyes can look dull and lifeless.

The most favorable orientation for a catchlight is between 10 o'clock and 2 o'clock above the iris. Once moved below the center axis of the eye, they won't look as attractive.

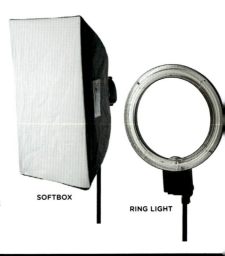

SOFTBOX

RING LIGHT

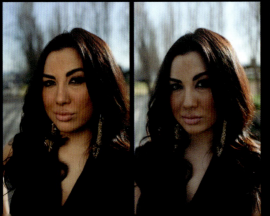

CATCHLIGHT ON VERSUS CATCHLIGHT OFF

The far left image shows our model with warm light thrown by a gold reflector bounced on her. The reflector provides a lovely light in her eyes—a very noticeable difference when you compare it to the picture left, which was taken without a catchlight.

Eye Reflections

Softbox lights will create rectangular catchlights in the eye, a reflector or single dedicated catchlight will give a round light to the eye, and a ring light will create a more stylized look.

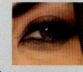

SOFTBOX

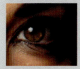

SOFTBOX CATCHLIGHT

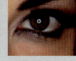

RING LIGHT

Ring Light

In a ring light, a fluorescent ring provides a very broad, even diffusion of light. The benefit of this flat, soft lighting is that it casts minimal shadows. When used on a face, a fresh, clean, and even look is produced. Another advantage of using a ring light is the catchlights that are produced—the small ring-shaped reflection gives the eyes a sparkle and a very distinctly stylized look.

A ring light is typically mounted so that it surrounds the lens of the camera. By placing your ring light on the same axis as your lens, you'll evenly light your subject. Ring lights are also incredibly helpful for capturing clean product shots.

The Basics

Getting the Best Results

LIGHTING & AUDIO

49

Basic Tools

Shooting Video

Post production

SOFTBOX CATCHLIGHT

The light from the softbox is much cooler than that from the reflector, and the catchlights in the model's eyes are rectangular.

RING LIGHT

Catchlights from a reflector are possibly the most distinctive. They are circular, ring-shaped lights, and very flattering.

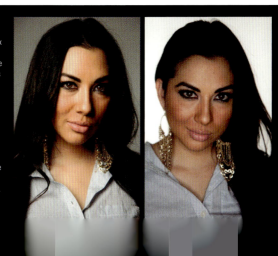

Reflector

In a controlled environment such as an indoor set, lighting your backdrop and subject are a matter of how you use the tools that you have. In a non-controlled setting like the outdoors, unfortunately, you cannot dial down the sun or instantly add more light to areas of shade. For these times the use of a reflector is invaluable. This technique can be applied in both controlled and non-controlled settings. A reflector will redirect available light onto your subject.

Subject's Back to the Light Source
The sun at high noon can cast harsh shadows on the subject's facial features, creating an unflattering effect. Harsh sunlight can also cause the subject to squint, which can be unattractive. By turning your subject's back to the sun, the sun casts an edge light on them while the reflector reflects light onto them, therefore acting as a fill light. The reflector allows for proper exposure of both sky and subject and gives a softer, more even light to shadowy areas.

Subject in Shade
Soft shade provides soft, evenly diffused lighting. The downside to shooting in the shade is that the subject can be underexposed in comparison to the background sky. Using a reflector as a fill light in this situation is effective, as lights are not always a powerful enough source of light in daylight conditions. Reflectors are lightweight, portable, electricity-free, and combine the power of solar energy with the control afforded by directional bounced light.

The reflector can be held in any orientation to redirect the sun's light from above, below, or either side of your subject. Utilizing multiple reflectors will introduce more light into your shot.

SILVER/WHITE
A silver/white reflector does not add a color cast, but will simply reflect the light back onto the subject.

REFLECTOR

Reflector Types

The Basics

Getting the Best Results

LIGHTING & AUDIO

51

Basic Tools

Shooting Video

Post-production

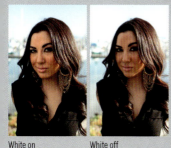
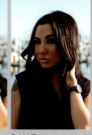

White on White off

Gold on Gold off

White
A white reflector will introduce a softer, more matte light. Experiment with holding it far away and closer—it is a matter of debate on which gives the best effect.

Gold
This reflector is made to add warmth to your shot. Gold produces a warm and bright light, and overall glow to the subject.

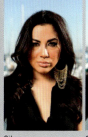
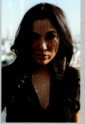

Silver on Silver off

Silver/Gold on Silver/Gold off

Silver
Metallic reflectors in general will make the reflected light more specular, as the reflector acts almost like a mirror. You will have more contrast with silver than with a white reflector, as well as a cooler color temperature.

Silver/Gold
A silver/gold reflector will reflect more of a yellow color, warming your subject. Outdoor light in the shade tends to be cool or blue so the addition of a golden cast to the subject will have a warming effect.

Introducing Audio

When making videos on your DSLR, the quality of your audio is just as important as that of your visuals. In fact, it could be argued that people are more willing to sit through bad video than terrible audio. The images in film will always speak to people on a multitude of levels, but the audio, on the other hand, cannot suffer from a lack of attention. Poor audio is excruciating and most audiences won't accept it. The bottom line is that you must capture quality audio. The good news is that there are many tools out there that will help you achieve professional sound recording.

Despite the ease with which they capture high-quality images, DSLR cameras severely lack the capacity to do the same when capturing audio. One of the major pitfalls of shooting video with a DSLR is the audio department—the cameras were just not designed to record the same groundbreaking quality of audio as they do visually. By learning basic audio-capturing practices, you will understand why the use of additional equipment really is an inescapable measure when shooting video on your camera. We're going to take an overview of the foundation of audio recording, then explore what factors determine the quality of sound. Understanding how to properly capture sound will allow you to choose the best options for each given situation.

Signal to Noise Ratio

Also read as SNR or S/N, your signal-to-noise ratio is the measure of your desired signal as compared to your background noise, or the ratio of relevant to irrelevant sound information. Expressed as an equal ratio, SNR would look like this—1:1. The goal of capturing sound is to maximize the signal and minimize the noise.

Signal The signal is the meaningful audible information. The information that is intended to be communicated is the signal and it is necessary for this to be as clear as possible. Let's use an example situation of a man talking on a telephone in his apartment to illustrate a few audio terms. While the man is speaking, the signal is his voice, giving the viewer the meaningful information, which in this case is the dialogue. Dialogue should be recorded in mono, which is closest to what the human ear will pick up.

Noise (including Electronic) Noise is the unwanted signal that exists within the environment you are shooting in. The noise present will vary with each situation, but will reduce the clarity of the signal you want to capture. In our example of the man speaking on a telephone, the noise might be the traffic outside the window, an airplane flying overhead—essentially any extraneous sounds other than the man's voice are considered noise. Electronic noise is another factor to consider. Cameras and even Image Stabilization mode can give off electronic noise that you may not initially detect while shooting. You need to be aware of any contributing factors of noise that may potentially be introduced into your audio.

The Basics

Getting the Best Results

LIGHTING & AUDIO

53

Basic Tools

Shooting Video

Post-production

Ambient Ambient noise or ambience consists of the background sounds within a given space. Every location has distinct consistent and inconsistent sounds created by its unique environment. What are the ambient sounds in the environment of the man speaking on a telephone in his apartment? The sound of people passing by on the street outside of his window, perhaps other people in the apartment. All of these sounds create the present ambience within his environment. Being aware of these sounds on each audio track will give consistency and a reinforced sense of establishment to your video. Ambience should be recorded separately in stereo sound, as it is used as a separate track in the sound-editing process. Combining it with the other audio will blend the entire piece together to create your final uniform track.

Presence or Room Tone There is a unique presence or "room tone" created in every environment according to the position of the microphone in relation to the space boundaries. Even though sound is being recorded in the same room or space, the positioning of the microphone in relation to the space will change the way the room tone sounds. This is due to the unique spatial relationship between the microphone and any boundaries present. In our earlier example, the walls, ceiling, floor, furniture, window, phone—anything in the space of the man's apartment will affect the room tone.

Room tone is recorded separately during filming, and should be captured after each scene with all of the characters and set exactly where they were placed for the specific scene. If the man didn't take a long enough pause while he was speaking on the phone and the editor wants to cut to a shot of the man's apartment screen with no dialogue, the same room tone is needed to keep the scene consistent. These aspects of sound capture are key in creating a smooth soundtrack.

Room tone should be recorded like dialogue, in mono. Be sure that the microphone used for the recording is in the same position and orientation as it was for the original dialogue recording, and that the environment is exactly the same as well.

Recording room tone is also helpful to keep voiceovers consistent in sound. The subject may record the voiceover (VO) in a different location. To avoid having a clear break in sound continuity, mixing in the VO with the room tone captured on the shoot will blend the new audio with the existing in a way that sounds seamless.

Three Tips to Capture Quality Audio

Optimize the signal-to-noise performance

Get your microphone as close as you possibly can to your subject—this will give you a much better chance of being able to capture quality audio. For this reason alone using the microphone built into your DSLR is not advised, as not only does the on-camera microphone pick up everything within its range, it also will not be at an optimal distance to your intended signal. You should aim to maximize the signal and minimize the noise. Bringing the microphone close to the subject is step one in ensuring a desired signal-to-noise ratio, so choosing a microphone that best suits your situation is going to be an important factor to consider.

Select the right type of microphone

Microphones come in all different kinds of polar patterns. Polar pattern refers to the different types of directional response patterns that microphones have. Only if you understand your polar patterns can you then select the best microphone for your situation and environment. For example, if you're capturing room tone for a separate audio track, a shotgun microphone with a narrow pickup range won't be the best choice. A much better option is an omnidirectional microphone—these have a polar pattern that picks up sound from all directions. This type of microphone will most accurately capture and record the room tone. In addition to the polar pattern, you want to take into consideration what style of microphone is appropriate for the situation. For interviews, lavalier microphones offer a discrete solution and can alleviate the problems posed by back and forth passing of a handheld microphone.

Optimize your recording equipment

Understanding your recording equipment and how to properly use it will ensure that you get the most out of it. You can own a Ferrari, but if you don't know how to drive, that car isn't serving its full potential. The same goes for your audio gear. Knowing how to maximize the capabilities of your equipment will almost always produce the best results. This applies to your external recording device, microphones, or field mixer. Knowing the functions and the capacity will enable you to best use the gear.

Stereo and Mono Sound

Stereo

Stereo (stereophonic) sound is the reproduction of sound using multiple independent audio channels and passing them through speakers in such a way that creates the impression of sound coming from various directions, as in natural hearing.

Mono

Mono (monophonic) sound is the reproduction of sound using a single channel. There is usually one microphone, one loudspeaker, or (in the case of headphones and multiple loudspeakers) channels are fed from a common signal path.

The Basics

Getting the Best Results

LIGHTING & AUDIO

55

Basic Tools

Shooting Video

Post-production

Polar Pattern

The polar pattern of a microphone refers to the different types of directional response pattern that it has. A polar pattern is designed to show you from which directions a microphone will pick up sound. It is helpful to remember that a polar response is always read in three dimensions: from the side, the top, and the front. Understanding your microphone's polar pattern will allow you to choose the best type of microphone for your situation and give you insight on how to position it for optimal results.

Omnidirectional

An omnidirectional microphone picks up sound from all directions, meaning he pick-up pattern has an even pick-up response in all directions. For this reason, omnidirectional microphones do not produce a proximity effect—an increase in bass or low-frequency response when a sound source is close to the microphone. Omnidirectional microphones are best suited to the situation of recording groups or interviews.

Directional

Directional microphones are designed to pick up sound from a specific direction, most usually from the front, while rejecting sound coming in from all other directions. Directional microphones are broken down into the three specific polar pattern types: cardioid, hypercardioid, and shotgun.

OMNIDIRECTIONAL

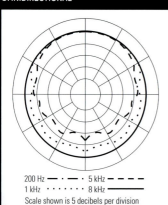

200 Hz ——·—·— 5 kHz ———
1 kHz ····· 8 kHz ———
Scale shown is 5 decibels per division

DIRECTIONAL

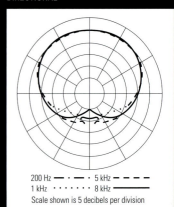

200 Hz ——·—·— 5 kHz ———
1 kHz ····· 8 kHz ———
Scale shown is 5 decibels per division

Cardioid

A cardioid microphone has a heart-shaped pick-up pattern. Cardioids are best suited to picking up sounds from the front, but are susceptible to plosives. Plosives are the sounds created by pockets of air, for example, when you say the word "plosive" the harsh "p" creates a plosive. Cardioid microphones are versatile and most commonly used as handheld stick mics.

Hypercardioid

Hypercardioid microphones are very similar to cardioid, but have an even tighter, more exaggerated pick-up pattern. Hypercardioids have better side-sound rejection than cardioids, though they do tend to pick up some sound from the rear.

Proximity Effect

The proximity effect is audio distortion that results in an increase in bass frequencies. This happens when the microphone is very close to the sound source. Directional microphones are affected by this, where omnidirectional mics are not. The reason for this is extremely complex, but very simply put, it is in part due to differences in pressure.

Shotgun

A shotgun microphone is the most highly directional type of microphone, and has a very narrow pick-up pattern. A shotgun microphone rejects off-axis sounds and, like a hypercardioid, will also tend to pick up sound from the rear.

The Basics

Getting the Best Results

LIGHTING & AUDIO

57

Basic Tools

Shooting Video

Post production

HYPERCARDIOID

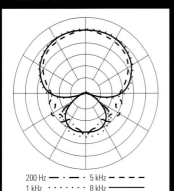

200 Hz —·—·— 5 kHz — — —
1 kHz ········· 8 kHz ————
Scale shown is 5 decibels per division

SHOTGUN

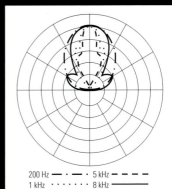

200 Hz —·—·— 5 kHz — — —
1 kHz ········· 8 kHz ————
Scale shown is 5 decibels per division

Common Types of Microphone

There are a variety of microphones out there with different polar patterns, functions, and capabilities. Now that you know what purpose each polar pattern serves, choosing a microphone that best fits your environment becomes a much easier task. Remember, the key to recording audio is getting the mic as close to the signal as possible. Using an external microphone will not only help you to do this, it will also eliminate any noise that would otherwise be captured if you were using only an external digital recorder or the built-in microphone on your DSLR. Let's take a look at two of the most commonly used microphones for shooting video on a DSLR.

Shotgun

Shotgun microphones are available in more than one polar pattern, though as we saw on page 57, there is a designated shotgun polar pattern. This pattern is specific to the design and function of a shotgun microphone. A shotgun polar pattern is extremely narrow. For this reason, when using this type of microphone to capture audio, some orientations are more favorable than others. Of course, this will depend on the environment and situation. Understanding the polar pattern will help you in deciding how to optimize the shotgun microphone's orientation and axis. We'll go further into this on pages 60–61. Beyond orientation, making sure the shotgun mic is treated properly will help eliminate the introduction of unwanted noise.

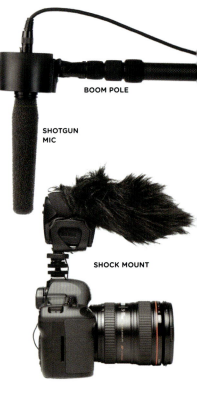

BOOM POLE

SHOTGUN MIC

SHOCK MOUNT

Shock Mount A shock mount is essentially a cage with rubber band webbing inside it to fit and suspend a microphone. This ensures that the microphone (and ultimately the sound) is not affected by any vibrations made by movement.

Windscreen Windscreens often go by the name "deadcat" or "furry." These covers are made with synthetic fur and fit over your microphone to block out the rumble created by excess wind noise. By simply adding a windscreen, you will reduce unwanted noise greatly.

Blimp A blimp, sometimes referred to as a zeppelin, is a hollowed capsule that fits around a microphone. These are often covered with deadcats to ensure that virtually zero wind noise is picked up. The still air that surrounds the microphone inside of the blimp is what makes it such an effective tool.

Lavalier A lavalier microphone, also called a lav, typically clips onto the lapel, tie, or shirt of your subject. The point of a lavalier is to get the microphone as close to the signal as possible. In this case, the signal is the speaking voice of the subject. Some examples of lavalier microphone use include during interviews, on the news, and in the theatre.

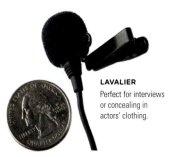

LAVALIER
Perfect for interviews
or concealing in
actors' clothing.

Lavs are designed to communicate either through a wire plugged directly into a mixer, an audio recording device, or wirelessly, with a radio frequency transmitter belt pack.

The polar pattern of a lavalier microphone is not fixed, as they come in different polar patterns to serve different purposes. For interviews in studio setups, I've found that omnidirectional pick-up patterns work best. The signal is captured more evenly as it is being picked up from all directions. I have found that omnidirectional lavs are more resilient to a lot of plosives than unidirectional lavs. To effectively regulate harsh audio peaks, there should be a dedicated audio technician to monitor the sound quality of the recording. Omnidirectional lavalier microphones can also be pointed downward as an additional precaution to avoid any peaking while recording audio.

Suggested Orientation of an Omnidirectional Lavalier

The practice of pointing an omnidirectional lavalier downward is sometimes used to help avoid those harsh plosives that can oftentimes happen when the microphone is very close to the subject. This won't always help, however, so use your judgement in testing out what sounds best for your given situation and microphone.

The Basics

Getting the Best Results

LIGHTING & AUDIO

59

Basic Tools

Shooting Video

Post-production

Microphone Orientation & Mounting

Boom

Booming is a technique where the microphone is attached to a boom pole and held out at length as close as possible to the sound source. The microphone is suspended either overhead or underneath the subject and out of frame. When a boom pole is being used, it is crucial for the microphone to be placed inside a shock mount. This will absorb any noise caused by vibrations created in the movement of the boom operator. The boom pole shown here is by Professional Sound Company.

For the operator holding a boom pole for extended periods of time, fatigue is an issue. Boom poles made of carbon fiber are lightweight and make for easier operation and transportation. Boom poles that extend and retract in sections are more versatile, as you will not be stuck with a fixed length to work with. Check also to see if you are able to securely lock the sections—collar or twist-locking systems are common. Look for an internal cable connecting the microphone to the recording device at the bottom of the pole. Male and female XLR cable connectors should be at the top and bottom of the pole; these enable connection to both the microphone and recording device. All of these features are not necessarily required as much as they make for an easier and efficient workflow for the boom operator and overall production.

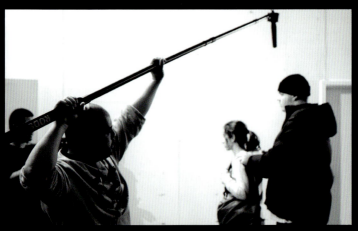

BOOM POLE AND MIC

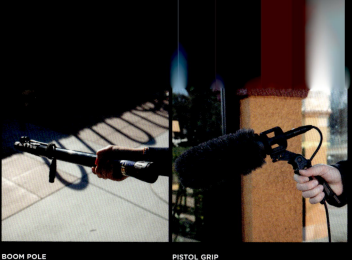

BOOM POLE

Placing the mic as close as possible to the sound source is essential for high-quality sound.

PISTOL GRIP

When holding the mic the pistol grip will stop any unwanted vibrations being picked up.

Pistol Grip

A pistol grip is designed to hold the shock mount and microphone, while an arm acts as a boom pole in situations where a one cannot be used. When and why would a pistol grip be a preferred tool over a boom pole for capturing audio? In situations where small spaces are too tight to accommodate a boom pole, the audio operator can capture and record with a pistol grip. The shock mount placement for the microphone is what keeps the audio capture clean while situated on the pistol grip. It is important when shopping for a boom pole or a pistol grip to be sure that a shock mount is either included, or that there is a place provided to mount one. Any vibrations or sharp movement from the audio operator can be picked up by the microphone and will compromise the quality of your audio capture. A shock mount is designed to prevent this.

Plant

A plant can be any type of microphone that is "planted" on a set or in a scene so the microphone itself is concealed, but still picks up the sound effectively. When using a microphone as a plant, you still want to be certain that it is positioned as close to the subject as possible. This is not an ideal method of capturing audio, although it can work successfully. In the case that you are using a plant to capture audio, check the sound. If you are capturing audio at the quality of your standard microphone, then this method can work well.

External Audio Recorder

As we've already discussed, DSLRs are notorious for having almost laughable in-camera audio capabilities. The bottom line is this: you are not purchasing this camera for its outstanding audio capture—this is not what your camera is designed for. While shooting videos with a DSLR, your new best friend is going to be an external audio recorder. To capture the best sound, you will need to couple your external audio recorder with external microphones, and possibly a clapper slate. A good audio kit is just as important an investment as your lenses.

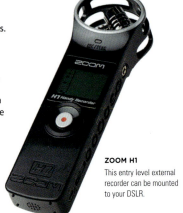

ZOOM H1
This entry level external recorder can be mounted to your DSLR.

Double-system shooting is the process wherein the visual and audio principles of the film are recorded separately and then later synced in the post-production process to form a single system combination of the two-into-one video file. This is an extra step, but an essential one. Later in the book on pages 174–175 I cover how to sync audio and video as easily and efficiently as possible.

Having an assigned person to monitor and manage all of the audio while shooting double system is going to save you from having to be a one-man band. Juggling the audio and visuals can seriously compromise one or both. If you can, having an audio tech on-hand is your best bet for shooting DSLR videos.

Clipping and Gain

When an amplifier tries to create a signal with more power than its power supply can produce, it will amplify the signal up to its maximum capacity, and then the signal can be amplified no further. The signal cuts, or clips, at the maximum capacity of the amplifier, and so is said to be "clipping."

If the gain isn't correctly adjusted on your recording device, all of the audio can take a flying leap straight into the trash. It will take some hands-on practice for you to get to know how to detect and prevent clipping, but before you record audio on-set, it is essential that you understand how to properly adjust the gain settings. First, if there is an automatic gain control (AGC) setting, disable it. As is usual, you

The Basics

Getting the Best Results

LIGHTING & AUDIO

63

Basic Tools

Shooting Video

Post-production

will want full manual control of your settings. AGC can create unfavorable highs and lows that sound terribly artificial and can totally ruin your audio. The industry rule of thumb is to keep your signal on the meter at about -20dB. Allowing the meter to jump between -6dB to -12dB is fine, but don't stray too far beyond this margin.

Automatic Gain Control

Automatic gain control adjusts the gain control for high or low signals coming into the sound recording device automatically. Keep it disabled.

Phantom Power

Phantom-powered audio recording devices will need to be powered by whatever they are plugged into. Some devices provide phantom power by generating the required voltage to power such a thing as a microphone, for example. A benefit of phantom-powered devices includes smaller and lighter microphones. There is no need for batteries in mics that only require phantom power, however, some

microphones can be powered both by battery or phantom power. Don't use both power sources at the same time though, as this will damage your equipment.

Upward & Downward Compression

Dynamic range compression is most commonly called compression. Within a certain threshold (measured in dB), quiet or loud sounds are brought up or down as desired. Amplifying quiet sounds, while keeping loud sounds the same is called upward compression. Conversely, when loud sounds are quieted to a given point, leaving the quieter sounds alone, this is called downward compression. Audio compression is done by compressing the audio signal's dynamic range.

HN4
The DSLR industry workhorse for external audio recording. Lots of professional features and XLR cable compatible for your boom mic.

External Recorder Tips

• Set the recorder to record 24-bit 48 kHz WAV files.

• An 8GB card is enough space for a full day's shoot, but always have backups.

Field Mixer

A field mixer gives you the ability to mix multiple audio sources, adjust individual microphone levels, and it supplies a preamp for an improved signal-to-noise ratio. A field mixer has the ability to support XLR microphones, which provide a higher quality of sound than mini-jack microphones. The tone generators, faders, and limiters on a mixer let you fine-tune the signals and optimize the quality of sound you record. Multiple microphones can be plugged into the field mixer, but this does of course depend on how many channels your mixer supports. In addition to having more than one microphone input, a field mixer normally has multiple outputs, and therefore the output of the mixer can be fed into several sources simultaneously.

Tone
A tone generator allows you to standardize the levels of your other devices with the output level of the field mixer. This step will help you to avoid clipping and digital distortion within the audio recording.

Fader
A level fader grants you the ability to adjust each channel's audio input individually—very useful.

Limiter
A limiter ensures that an audio signal does not exceed the amplitude of the threshold.

AUDIO FIELD
A dedicated sound mixer can control the levels of multiple audio sources live on-set.

Why You Need a Preamplifier

The basic function of a preamplifier is to improve the signal coming in from the microphone and reduce the noise. A preamp will throttle the noisy amplifier in your camera and replace the noisy gain with clean gain. This, however, also minimizes the microphone signal level as well. To remedy this, a preamplifier then boosts the microphone level, ultimately improving the signal to noise ratio.

Mini Jack to XLR

Your DSLR camera does not have the right kind of connector for the best-quality microphones, as though the best-quality mics will have balanced XLR outputs, a DSLR comes with a stereo mini-jack input. A preamp like the JuicedLink or BeachTek will allow you to interface professional-level XLR microphones with your DSLRs stereo mini-jack input.

XLR OUTPUT

JUICEDLINK

Signal to Noise Performance

To achieve better signal-to-noise performance from camera amplifiers, a preamplifier manually throttles the amplification in the camera and replaces the noisy gain with clean gain, while boosting the signal to achieve optimal signal-to-noise performance.

Automatic Gain Control

Some preamplifiers will have an AGC disable option that will force the camera to throttle the noisy amplifiers. This is done essentially by tricking the camera with a high-level signal. This causes the AGC circuit to turn down its gain allowing the preamplifier to control the best signal-to-noise performance.

Post-production Workflow

External recording devices can sometimes add complicated audio syncing steps in post-production. Given the fact that DSLRs are only capable of recording around 15 minutes of footage at a time, syncing all of the audio for a large number of takes can become time consuming if you're not using programs that help to assist in this process. To cut back on the post-production process, preamps allow you to record directly into the camera. If you only have XLR mics plugged directly into your camera's mini-jack input with adapters, and try to throttle the noisy amplification in the camera, you will turn all of your audio down rather than the noise alone. Preamps allow you to cut noisy gain and boost your signal for better signal-to-noise performance.

The Basics

Getting the Best Results

LIGHTING & AUDIO

65

Basic Tools

Shooting Video

Post-production

Clapper Slate

Traditionally, clapper slates were used while shooting films as both an organizational system and also as a method for synchronizing audio. In a production of any scale, multiple takes can quickly become a headache once all of the completed footage is handed over to the video editor. Before each take, vital information is written on the slate to give the video editor reference points as to where each take belongs within the story's time sequence. Date, production title, director, take, and scene sequence are some of the necessary scoring points that a clapper slate should include.

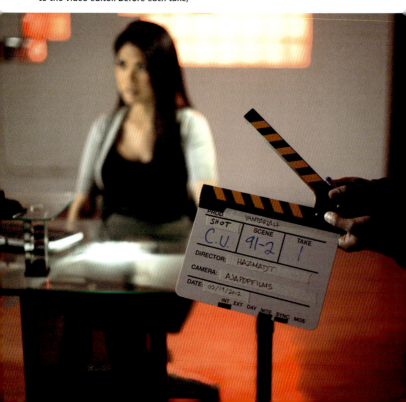

Clapstick

The clapstick is the top part of a slate that is slapped together. This action creates a loud clap that not only is heard clearly, but also shows visually in the audio file as a sharp spike. When the clapstick is snapped shut, the colored bars all line up, and provide a frame where the editor can line up the audio spike that the clap creates. The sharp spike can be clearly seen in an audio file and makes for easier syncing of the two separate video and audio recordings in post-production.

Modern technology has made digital clapper slates easier to read in any lighting condition and allows the crew to program and recalibrate without chalk or dry erase pens. The use of iPads and iPhones is growing in popularity on small productions and they are quickly taking the place of the traditional clapper slate for indie DSLR video shooters. Apps make it simple to input information that can easily be picked up by the camera.

CLAPPER SLATE ON-SET

Used as both an audio synchronization tool and shot marker, the clapper slate is an essential item when recording separate audio and video. The clapper slate also signals to the editor which scene this shot belongs to.

Speeding

Although it seems like a given, oftentimes a slate is clapped before all cameras and audio are rolling, or "speeding." The term speeding is used in reference to actively recording media. Before each clap, be absolutely sure that all cameras and audio are rolling. Calling out phrases like, "Camera 1 speeding, camera 2 speeding, audio speeding," and having each operator repeat back to confirm, is a common practice I use before each take. This is one simple practice that ensures time efficiency and prevents any cutting-room meltdowns. On small sets, where some operators are in charge of both a camera and audio at times, small oversights can be made, and this is a habit that can save a lot of retake time.

Clapper Slate Alternatives

If you're working on a shoestring budget and a clapper slate, iPad, or iPhone is not within your production means, having the talent clap their hands before each take will suffice. Another clever trick we use while shooting quick interviews in the field is a dog clicker. These are used to train dogs. It is a tiny clicker that fits in the palm of my hand. I make a few clicks, which are picked up by both the camera's audio and the portable recorder's audio. Later in post, we sync the two audio tracks with the sound spikes the clicker created. In any editing software, sound shows up as waves. Loud sounds spike or peak, and these peaks give a reference point as to where the audio and video should be synced up.

The Basics

Getting the Best Results

LIGHTING & AUDIO

67

Basic Tools

Shooting Video

Post-production

BASIC TOOLS

Now that you have your DSLR camera, making captivating videos is within your grasp! Yes, you could just go out and begin to shoot, but first there is a long list of equipment available that is designed to help you get the most out of shooting video with your camera. Knowing the basics and how these tools work will help you build a store of knowledge that you can always refer back to and expand on.

The Basics

Getting the Best Results

Lighting & Audio

BASIC TOOLS

Shooting Video

Post-production

TRIPOD

To capture a low-angle, low-light outdoor shot, a tripod that adjusts to a very low level is essential.

TRIPOD HEAD

The size of the head you go for should be determined by the size and weight of your camera. For large, heavy cameras you will need at least a 100mm tripod head.

Of course, you will not need every piece of equipment that we discuss. It's important to remember that necessity is the mother of invention, and that great things have been done by cinematographers working with very little.

That said, what you do need depends a great deal on your style as a video shooter, as well as what kind of video you're trying to create. If money is no object then that's great, but if you're on a budget, make a list as you read, then highlight the essentials for your project. It's easy to be lured in by the latest gadgets and gizmos, but keep your feet on the ground and remember it's better to spend your money on a solid, basic kit first.

Support

Steady shots are what separates the pros from the amateurs. Support and fluidity are key in videography. Too much shake in your footage will have your videos looking like those old home movies your father shot on his camcorder back in the 1980s—you don't want that. Support for your DSLR serves as a staple piece that no video shooter should be without.

Tripod

A tripod will give your camera a steady anchor point to shoot from. There are photography tripods and video tripods. The difference is that a video tripod will come with a head designed for pan-and-tilt movements. If you're just buying the base legs, you will also need to be aware that the video tripods come with locking screws on the platform where the video head will be attached. Without the proper locking screws, your video head can come loose during panning.

I've reviewed a lot of tripods and have been asked most commonly what the best-quality tripod is for the least amount of money. The bottom line is this: you get what you pay for. You don't need to break the bank, but don't expect much out of a twenty dollar set of sticks. If you plan on adding to your camera setup, take into account the maximum payload on the tripod, maximum height, minimum length when collapsed, and overall weight of the tripod for travel. An ideal weight limitation for a DSLR video shooter's tripod should be roughly around 8 pounds minimum. The maximum height will be based on how tall you are, so that you aren't hunched over when recording, or when you need height for a specific application. The minimum collapsed length and weight of the tripod is important if you plan to travel. Will you be carrying this on your back during a hike, or will you be carrying the tripod onto a plane? It's not uncommon for one to own several different tripods, but the first one you consider should be able to address a majority of the situations you plan to use it with.

Bowl Mount

A bowl mount has a bowl that the fluid head sits on top of. The common mount sits on a flat base plate. The benefit of having a bowl-mount tripod and video head is that when your camera is not level, by adjusting the orientation from the bowl you can straighten out your camera without having to do so from the legs. For the common-style video tripods, level your horizon by adjusting each leg one at a time. Adjusting from the legs can be tricky and difficult, especially if your camera is already mounted with weight added.

Regular Mount

A regular mount type tripod has a flat stage above a telescoping center column. The video head is attached with either a 1/4"-20 threaded stud or 3/8"-16 threaded stud. These types of tripods must be leveled by using the legs for adjusting the height to compensate for uneven ground. The benefit to having a regular mount is that the shooter can

take advantage of the adjustable neck on this type of tripod. The maximum leg height on these tripods doesn't limit the overall maximum height, since the neck can be extended.

Tripod Positioning
Be aware that the positioning of your tripod is important. With a large lens, the camera can become extremely front-heavy. Positioning the tripod so

two legs are providing more support for the front of the camera helps to ensure that it doesn't topple forward.

The Basics

Getting the Best Results

Lighting & Audio

BASIC TOOLS

71

Shooting Video

Post-production

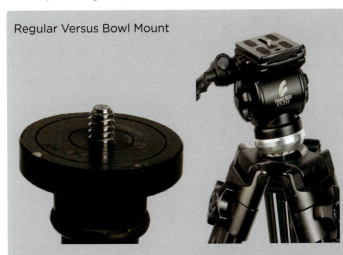

Regular Versus Bowl Mount

Regular Mount
Traditional stills camera tripod mount that requires the adjustment of the tripod's legs to level the camera.

Bowl Mount
Traditional video camera tripod mount that enables leveling of the camera on uneven ground without adjusting the length of the tripod's legs.

Monopod

While a monopod doesn't give you the solid stationary stance of a tripod, it is great for event shooting and portability. Monopods also offer the versatility to get creative shots, along with having a compact build operateable from places that tripods cannot go. Some locations with a large number of visitors do not allow the use of tripods, but allow the use of monopods. A speedy setup and take down is also a huge benefit. The monopod usually only has one leg or one point of contact with the ground. However, some monopods have small feet that extend out to supply added support and can even stand independently from the operator.

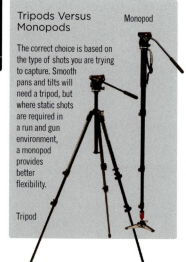

Tripods Versus Monopods

Monopod

The correct choice is based on the type of shots you are trying to capture. Smooth pans and tilts will need a tripod, but where static shots are required in a run and gun environment, a monopod provides better flexibility.

Tripod

Fluid Heads

A fluid head gives you the ability to pan and tilt in smooth, fluid motions. A true fluid head will have an adjustable fluid cartridge that will allow you to control the amount of dampening. Cheaper video heads use the term "fluid head" when they apply a very heavy, thick, sticky fluid between the pan-and-tilt joints. Although you will feel the drag of the fluid, it can't be controlled for faster or slower pan/tilts. The knobs they provide simply lock the video head from any movement. The more expensive fluid video heads will allow you to adjust dampening on how fast or slow you should control your pan/tilts, along with compensating the amount of weight being carried on the fluid head. Whether you decide to use the cheaper type or more expensive type, for shooting videos on your DSLR a quality fluid head is a must. Jerky movements are a sure sign of poor camera operating.

True Fluid Head What is a true fluid head? Fluid cartridges are essentially a system of two moving parts that slide, one over the other, separated by a fluid specific to the manufacturer. The goal is to create a completely frictionless pan and tilt.

A friction-based video head uses metal plates or nylon washers separated by thick grease or silicone to mimic the fluid motions of a higher-quality "true fluid head" for smooth starts and stops and decreased jerking. True fluid heads are a lot more expensive, but worth the results. The main difference between these two types of fluid heads is the overall

Fluid Heads

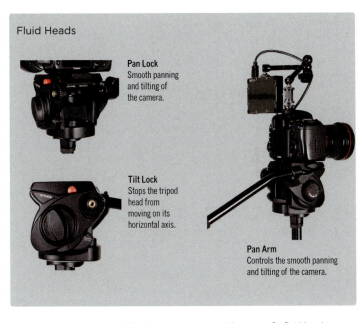

Pan Lock
Smooth panning and tilting of the camera.

Tilt Lock
Stops the tripod head from moving on its horizontal axis.

Pan Arm
Controls the smooth panning and tilting of the camera.

The Basics

Getting the Best Results

Lighting & Audio

BASIC TOOLS

73

Shooting Video

Post-production

construction and elements within the head. True fluid heads will render zero friction, while basic video heads will deliver jerky movement with heavier payloads.

Counter Balance Not all video heads will include a counter balance. A counter balance will help to ensure your camera doesn't fall forward or backward. It can be adjusted to your camera's weight so that you can tilt downward or upward without having your camera fall on its own weight due to gravity. The goal is to use the counter balance to work for you so you are not fighting either gravity or the spring back of having too much counterweight.

Pan Arm The point of a fluid head is to be able to pan and tilt your camera when shooting videos. A pan arm is required to do this effectively and provides the leverage to control the fluid head smoothly. A pan arm will be supplied with your fluid head.

Pan-and-tilt Lock A locking feature for pan and tilt ensures that in any fixed orientation, your camera is not going to move. Whether you are shooting products, environment, or films, at some point the camera is going to need to be fixed in a position that is static in a pan or tilt. This feature will be beneficial to your workflow.

Buying Tips for Tripods, Monopods, & Fluid Heads

Quick-release Plate

The quick-release (QR) plate is what attaches your camera to the tripod, monopod, and fluid head. It is called a quick-release plate because it allows your camera to be released from the video head very quickly without having to unscrew the 1/4" or 3/8" screw each time you want to move the camera. Some QR plates come with a slot that enables you to center the 1/4" or 3/8" screws along the length of the plate.

Maximum Payload

Always keep in mind the maximum amount of weight your support gear will take. Knowing that your camera and entire setup will be resting on this equipment, you need to ensure that it doesn't buckle under the weight. A good rule of thumb that I use is to overshoot by a few pounds. Maximizing the suggested payload may result in compromised performance. Additionally, if you plan on building up in the future, any weight added should be taken into consideration.

Construct

The elements that your equipment is made of can make a huge difference not only to the performance and quality (not to mention price point), but also the weight of it. Tripods made from aluminum are much heavier than those constructed from carbon fiber. If you plan on traveling with your gear, learn what it is made of and how much it weighs—it will benefit you in the long run.

QUICK RELEASE
Quick-release plates give more control to balancing your camera when it is set up on a stabilizing unit.

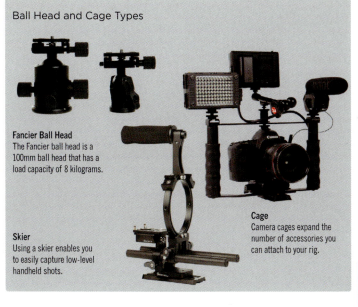

Ball Head and Cage Types

Fancier Ball Head
The Fancier ball head is a 100mm ball head that has a load capacity of 8 kilograms.

Skier
Using a skier enables you to easily capture low-level handheld shots.

Cage
Camera cages expand the number of accessories you can attach to your rig.

The Basics

Getting the Best Results

Lighting & Audio

BASIC TOOLS

75

Shooting Video

Post-production

Ball Head

For video, a ball head will not provide the same amount of control that a video fluid head will. However, for fixed shots, a sturdy ball head that will lock the camera securely in place will get the job done. A ball head allows you to change the orientation of the camera angle at just about any degree. I advise against using a ball head in place of a video fluid head, as you will not see the same results. A ball head is also a great tool for mounting stationary shots on a slider, since the trolleys on sliders are at a fixed angle. The ball head gives you the control to articulate the camera and level the horizon in any orientation.

Cage

DSLR cameras were not designed to carry more than a flash on the hotshoe. With all the shortcomings of DSLR cameras, you'll find yourself adding microphones, portable recorders, receivers, transmitters, and LCD monitors—if not more. A DSLR cage is designed as a surrounding bracket that will allow you to mount all of these accessories to your camera so that they can remain attached as you move the camera about. Some DSLR cages have been designed with wide-spaced handles. By moving your hands further away from the camera you will reduce the micro vibrations from unsteady hands and the cage can be used as a type of stabilizer.

Video Rig

Technically, a video rig can be anything, but today the term is mostly used to mean a special set of industry standard-sized rails and clamps configured in various ways by the operator. These video camera rigs are modular pieces that can expand or retract in size to accommodate not only the camera, but also the gear the shooter requires. A majority of the rigs you'll find follow an industry standard so that you can mix and match parts and accessories. For this reason, you can pick and choose pieces from a variety of manufacturers and put them all together onto one rig using key pieces such as rods, clamps, and screws, follow focus systems, matte boxes, handles, and more.

A rig can be configured to introduce more points of contact to increase stability and support while shooting, to decrease the hand-to-camera contact, and remedy shaky handheld movements.

Additionally, a rig is going to give you an increased area to mount accessories onto. Your DSLR only has one hotshoe that will provide electronic connectivity to your camera. An external flash needs to be able to communicate with your DSLR when shooting photography, but for equipment that doesn't require the need for electronic communication, like a shotgun microphone or LED light, mounting on a rig will allow for greater distance between the equipment and a secure place for it to be attached. While shooting video on your DSLR, none of the supporting lighting or audio accessories need to communicate with the camera, so you can fully utilize a rig to hold anything you might require for your shoot.

A rig system should be configured to distribute the weight of a camera and its accessories more evenly onto your body to reduce muscle fatigue during long shooting sessions. The configurations can be endless and tailored specifically to the individual. Let's take a look at what these are composed of and which pieces you should be looking for to let you modify different pieces with one central rig:

15mm Rods

Industry-standard rods can be found in both 18mm and in 15mm OD (outside diameter). For DSLR video the more popular standard will be the 15mm version. Rods come in different designs, coatings, materials, colors, and length. Anodized metal with gripping can provide less slippage while in contact with the clamps and so create much less movement if you have to support a heavy setup.

Clamps

Clamps enable you to attach equipment onto your rods, and vary in quality and make. Clamps are like the glue of your rig. If you're planning to build up and add more gear to your setup, make sure to get a variety of clamp styles.

Shoulder Mount

On a rig setup, your shoulder mount is what will determine how stably the rig fits to your body. Some shoulder mounts will rest on top of the shoulder blade and

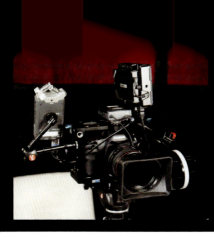

The Basics

Getting the
Best Results

Lighting & Audio

BASIC TOOLS

77

Shooting Video

Post-production

RIG SYSTEM
The new form factor of DSLR camera means they require a module rig to achieve professional-quality video, especially when it comes to handheld camera work.

others press into the armpit crease. When shopping for a rig, you'll want something that will contour to your body frame and also provide a soft cushioned surface so it doesn't become painful while you're shooting for extended periods of time.

Grips
Grips are what connect the rig to your hands. Grips come in all sorts of lengths and curves. The shorter grip handles enable you to tuck your elbows into your sides and draw support from your body's center of balance. With elbows tucked in, the arms have less of a range of motion, cutting back on movement. The longer handles will also provide you support against the trunk of your body. The elongated handles are more comfortable for some than others. Depending on your shooting style and body type, you should shop according to how your arms and movements best work with the grips.

Handle
On a camera cage or on a rig, you will find a handle for carrying and for holding the setup while shooting low-to-the-ground shots. Handles are convenient for transportation, especially on a cage.

Counterweight
Anytime you have a front-heavy setup, you need to counter balance in the back to give an even distribution of weight. Counterweights will ensure that the center of gravity is exactly where you want it to be. For a rig setup, the counterweights hang in the rear behind the shooter's shoulder. Most commonly, you will find these behind or attached to the shoulder mount. Counterweights should be able to be adjusted depending on your camera, lens, and any additional devices you have mounted on the rig.

Rig Accessories

Light

Light emitting diodes are hugely popular as on-camera lighting solutions. These lights are normally daylight-balanced with tungsten dials or gels. The advantages to utilizing LED technology as your on-camera video light are the lack of a heat factor, the compact size, and the portable battery power options that LED lights provide. LED lights can also attach to the hotshoe of your camera, and have an articulating head for angling. Portable LED lights can be attached to light stands if needed to be used off-camera.

Follow Focus

A follow focus is a specially designed geared system that makes contact with the focus ring of your lens, usually by a lens gear. A follow-focus system will allow you to pull smooth and more accurate focus than by hand. Most follow focus types will include a marking disc and marking indicator. You can use a dry-erase marker to set predefined points on the marking disc. This is for quick, easy, and accurate focusing when shooting at different distances.

External Monitor

DSLRs were not originally designed with the intention of shooting video. Since your eyeline isn't going to match that of the LCD display, you won't always be able to easily see exactly what you are filming. An external monitor is used as an aid so that you can see the picture you're shooting. There are also situations where

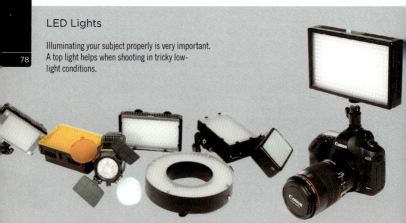

LED Lights

Illuminating your subject properly is very important. A top light helps when shooting in tricky low-light conditions.

The Basics

Getting the Best Results

Lighting & Audio

BASIC TOOLS

79

Shooting Video

Post-production

> TIP: The best way to focus correctly while composing your shots perfectly is to have someone else pulling focus. To pull focus means that while the camera operator is moving the camera for composition, there is another person focusing the shots. Having a viewfinder or an external monitor can help make this process easier, especially if you're operating solo.

a director or third party needs to see what is being shot in real time; an external monitor is also used for this purpose so several people aren't huddled around the back of the camera. Field monitors range from very simple and inexpensive to more complex with a variety of features.

Your basic monitor will display from the DSLR, but to take full advantage of an external monitor, there are a few key features to consider. High resolution and pixel density will provide you with a display you can see clearly, and help you focus. If the resolution of the monitor is poor or if the pixel density isn't high, your images will look softer and it will be harder for you to judge critical focus.

Focus assist is a feature that helps you to see where the image is in focus by highlighting edges in sharp contrast. If you are using a monitor that is not displaying in full 1080HD, achieving focus is slightly more difficult. Focus assist will outline the areas in focus in white or another very bright color as an overlay.

Follow Focus

Pin-sharp focus is critical when shooting video. A follow focus enables you to push and pull the focus ring when following moving objects through the scene.

False Color is a feature that will give you clear and easy-to-see colors for over- and underexposure. It will also indicate on a color scale when the scene is properly exposed. If you are shooting in bright daylight conditions, this feature is a life saver. Through different colors you can see if you are losing detail in the highlights or shadowed areas of your image, which can be a difficult thing to judge from the camera LCD or external monitor.

Peaking is a feature that purposely over-sharpens the image to give a frosted look to areas in focus. The exaggerated display is used to help visualize areas in focus without the use of colored markers. Zoom allows you to zoom in on your image from the monitor to get a closer look at a specific area.

DSLR full-screen scale mode gives you a scale and resolution closest to what you would see from your recording. If you are using an LCD monitor that does not display all of the recording pixels, you could end up with more lead room in your composition.

HDMI has so far been the common video output connection from most DSLR cameras. It can provide full HD display and audio to an external device. An LCD monitor that has both an HDMI input and output (pass through) will allow you to run a second monitor. Sometimes more than one monitor is required on the camera, or you can use the Pass Through setting to stream HD video out from a wireless transmitter to a remote display.

Component and Composite

Headphone output to monitor audio on playback: This feature allows you to hear the audio quality. Most consumer-priced DSLRs do not have a headphone output. If audio playback is important for your workflow, purchasing an external monitor with a headphone output is a good idea.

Some external monitors can be combined with an optional optical viewfinder and loupe, making it an electronic viewfinder (EVF) solution.

Optical Viewfinder

An optical viewfinder, also called a loupe, is an attachment that connects to your camera's LCD display to give you a magnified perspective while preventing extraneous light leakage. In order to be sure that you're achieving accurate exposure, focus, and framing, you must be able to clearly see your LCD display. Bright sunlight can wash out your display, so a viewfinder is used to give

Location Monitor

Both the camera operator and the director can check the shot's color balance, focus, and composition on a calibrated field monitor.

The Basics

Getting the
Best Results

Lighting & Audio

BASIC TOOLS

81

Shooting Video

Post-production

Electronic Viewfinder and Loupe

The addition of an electronic viewfinder to your rig gives you improved monitoring of the camera focus and exposure. Viewfinder adapters can be added to block out the light hitting the LCD and provide clear monitoring when focusing and exposing your shots.

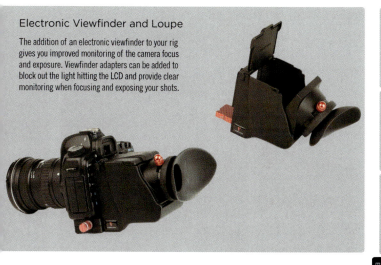

the DSLR the correct form factor for shooting video in these conditions.

Some optical viewfinders or loupes have a diopter that allows you to dial in the focus to match your eyesight. Having a diopter would be convenient where you need to remove your eyeglasses while shooting.

Electronic Viewfinder

An electronic viewfinder (EVF) is basically a very small monitor in combination with a magnifying loupe. Where a basic optical viewfinder must be positioned onto the back of your camera's LCD, an EVF allows you to remotely position your camera display in a way that is more ergonomic for the camera operator.

MATTE BOX

Matte Box

A matte box is designed to control the light entering the lens in order to prevent lens flare. Matte boxes can include flags at the top and/or sides. These block the light from hitting the lens in unwanted areas. They can also create lens flare in the case that the matte box is not deep enough. A matte box holds filters that can be rotated to achieve the best exposure results when using any type of filter.

Gear For Dynamic Camera Movements

Camera Slider

Video camera sliders are used to capture steadied sliding camera motions. Sliders are designed as either push pull or crank pulley systems. With a push pull slider, the camera is either pushed or pulled along a single axis track and rides on top of a trolley or sometimes called a carrier. The crank pulley system is moved by turning a crank that is attached to a belt. Sliding shots can be either horizontal or vertical. By adding a video head to the slider, this will allow you to pan and tilt while simultaneously sliding the camera. The two common types of camera sliders are friction based, and roller bearing. The type you choose will depend on your preference. I delve further into how to use a slider on pages 158–163.

Friction Slider

Friction camera sliders use a type of plastic or nylon sleeve that simply slides the camera along a hardened rail. These friction sliders do not roll along, and some prefer the amount of friction they provide to help control the movement of the sliding action. With uneven weight or excess weight on the carrier, these friction based sliders can bend.

Crane

Depending on your budget and environment, a camera crane can completely transform your videos. The flying effect that a crane will create takes the look of your videos from amateur to pro, hands down. A crane used for camera operation will have the camera operator on the actual device. The operator controls the movement of the crane mechanically. There is usually a separate operator to control the camera's zoom and focus features. When shooting video on a DSLR, this type of crane is probably not going to be used. Technically, the term crane refers to this machine specifically. Within the world of DSLR, you will likely hear the term "crane" used in reference to a jib.

Roller Bearing Slider

Roller bearing sliders are typically more expensive, and use plastic or metal bearings that actually roll the carrier along a hardened rail. The roller bearing type is very smooth and can normally carry much more weight without binding down the track. Without a way to control the amount of friction, it can be tricky to have a very consistent movement. Some roller bearing sliders will allow you to tweak friction by adjustment of the bearings.

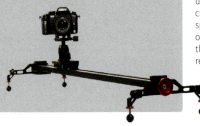

Jib

Unlike a crane, the jib doesn't have an operator on the actual device itself. Jibs are most often operated from a tripod. The jib works like a see-saw in that by weighing down one end, the other end is raised. The jib arm has counterweights at the back end and the point of balance is located closer to the rear so swinging arc movements can be made possible.

A jib sometimes offers tilting where the camera is placed. Otherwise, a hot head can be attached to give tilt control to the jib from the back rather than having to pan and tilt from the front where the camera is attached. From the back, the operator has control of the movements both on the front end of the jib and at the base, where panning of the jib arm itself can occur from the tripod.

Jibs vary in price and complexity. There are all types, from mechanical to manual, and each comes with a respective price point drawn accordingly. By using a tripod dolly to support the tripod and jib, the setup can be become mobile. You will also want to consider having a fluid head where the jib attaches to the tripod so swinging shots can be made possible.

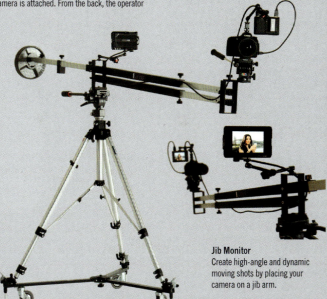

Jib Monitor
Create high-angle and dynamic moving shots by placing your camera on a jib arm.

The Basics

Getting the Best Results

Lighting & Audio

BASIC TOOLS

83

Shooting Video

Post-production

Table Dolly

For shooting videos on a DSLR, there are scaled-down table dollys made to support these smaller cameras perfectly. A table dolly gives you a stable anchor on wheels to achieve tracking and rotational shots with. For dollys that skate on flat surfaces rather than tracks, ensuring that the surface is smooth will make or break the stability of your shot. If your surface is bumpy or uneven, the footage will suffer and completely render the table dolly useless. There are two main types of table dollys available and most commonly used by DSLR shooters.

Four-wheel Table Dolly

A four-wheel dolly has two axles that can be pivoted for rotating in or out, tracking side to side, pushing, pulling or to get full rotational shots of a product. Traditional dolly systems include a ground laid track with a dolly that is operated along the single axis. For smaller shots and less elaborate budgets, skating dollys that use wheels with bearings run freely to track subjects much in the same way.

Three-wheel Table Dolly

The distinctive difference between a three- and four-wheel dolly is that a three-wheel device can perform full 360° shots with a single fixed point. The two axles on a four-wheel dolly can only be turned in a certain amount. The full rotational shot on a four-wheel dolly is tight, but cannot perform the full 360° in-place spin that a three-wheel dolly is capable of.

Flying Stabilizers

Steady camera shots are sought after by all operators. The purpose of a flying camera stabilizer is to absorb the shock that occurs with sharp movements by use of a gimbal. Flying stabilizers aim to give increased tilt and roll control with fluid motion, and create a floating effect for the viewer. When balanced properly, your camera's horizon will remain level, only moving slightly in smooth movement—even when running or climbing a staircase. Flying stabilizers have a few key elements. The camera stage allows the camera to be positioned and adjusted on an X/Y axis to properly balance the camera's horizontal setup according to the counterweight ratio. Every element of the camera's setup will contribute to its balance—including the memory card! Properly balancing a camera is just as important as flying it on a stabilizer, as one cannot be done without the other. A gimbal allows the camera load movements from the front end of the arm to rotate freely on any axis. A control ring provides pan and tilt control. The vertical balance is a set of weights that counters that of the camera for even distribution.

Handheld Versus Vest with Arm

Stabilizers that create the illusion of a floating camera can be handheld or supported with a vest system. The vest system will normally have an attached frictionless articulating arm. When shooting handheld, the weight of the camera can cause fatigue in short time. A vest system will allow you to carry the weight of a stabilizer that is loaded with equipment so you can concentrate on the footage. The vest system is recommended if your camera setup is heavy or if you have a project that will require a long period of shooting time. A very popular stabilizer is the Steadicam. The Steadicam is a flying stabilizer attached to a vest by a frictionless arm. The weight from the camera's setup is held by the operator by way of counterweighting the payload. This is done by simply adjusting the friction control. If the camera is floating freely at any fixed position, the setup is properly balanced.

The Glidecam is one of the more popular gimbal-style handheld stabilizers. Handheld stabilizers also aim to create a floating look to the video by way of the balance achieved when properly set up. Similarly to the Steadicam, if the Glidecam stabilizer experiences no dropping and falling while being held by the operator, the counterweights are perfectly balanced. The perfect balance will give the camera a floating stage. This is the goal with all stabilizers.

One of the most common questions I am asked with regards to stabilizers is how to fly them. Although this takes practice, there are variables within actually setting up and flying a stabilizer that really determine how successful the venture is going to be. With patience and practice, the type of video footage that can be achieved from a flying stabilizer cannot be replicated in any other way and is very rewarding. I detail how to fly a stabilizer on pages 158–163.

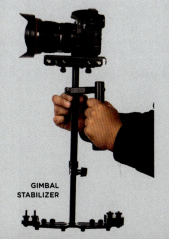

GIMBAL STABILIZER

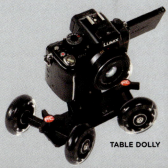

TABLE DOLLY

The Basics

Getting the Best Results

Lighting & Audio

BASIC TOOLS

85

Shooting Video

Post-production

Battery Power

Your DSLR and a good amount of the equipment you use to shoot video will require some form of power. Drawing that power from batteries is the easiest way to do this as they are portable and require no cords or AC outlets. Besides being sure that all of your batteries are fully charged before going on any shoots, you should also be sure you're maximizing the performance of what you're working with.

Battery Grip
A battery grip is an extension on your camera to add life-span to your working time. A battery grip will not only extend your run time, but also will alleviate having to change batteries often and have multiples as backups.

FULLY CHARGED
For an all-day shoot you'll need multiple batteries. Read the manufacturer's guidelines and work out how many you need—then take an extra, just in case.

Rechargeable Batteries

Devices like an external audio recorder will require AA batteries for power. Having a set of good rechargeable batteries will keep costs down. Just be sure that before your shoot your batteries are all fully charged.

Portable Power

A portable battery pack is an option a lot of people aren't familiar with or don't know much about. The versatility that comes with having voltage you can hold in your back pocket upstages conventional rechargeables, hands down. A pack like the Tekkeon will provide DC power and adapter tips. You can dial in the voltage output you desire and it will run LED lights, gadgets, laptops—you name it. This is an awesome power solution for those on-the-go shoots where you don't want to plug into a wall or carry around buckets of batteries. Just be sure to verify that the gear you are powering is compatible with the battery pack.

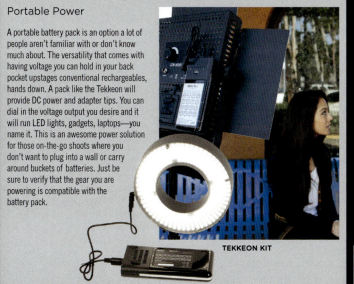

TEKKEON KIT

AC Power for the 5D or Other Cameras

An AC power adapter plugs into a wall socket and connects to a dummy battery pack that goes into the battery slot on your camera. If you need to power your camera for extended periods of time, this solution will enable you to do so without having to worry about a battery.

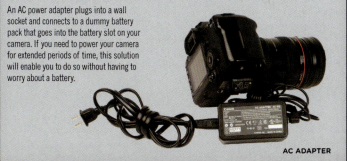

AC ADAPTER

The Basics

Getting the Best Results

Lighting & Audio

BASIC TOOLS

87

Shooting Video

Post-production

Grip

Friction Arm

Friction arms are also referred to as "magic arms." These tools give you an arm that can be configured in any orientation. With male and female threading, these attach anything compatible together. The possibilities are endless. Friction arms act as an articulating solution for any setup you can imagine. This is one tool I never work without.

Magnetic Fastener

As a quick-release adapter alternative adapter for accessories, magnetic fasteners are reliable and heavy-duty. Trek Tech makes a mag system that consists of a base with a standard 1/4–20 thread and sits flush on any base. The mounting plate that attaches to your accessory is available in different densities so that you can have a fairly strong bond. Another type of adapter they offer is the ball head MagMount Star with a safety latch. They even offer a much larger pro version of this anti-rotation toothed ball head MagMount with safety latch.

As for how safe magnets are around digital equipment, I've looked into this and they don't have the same effect on LCD screens and flash media storage. Old cathode ray tube (CRT) monitors used a magnetic field that could be interrupted with a simple magnet. LCD screens do not work that way. Compact flash and Smart Media cards (solid state) are also not affected by magnets like this. It is a very safe system. Especially once you have mounted the plates to the base, the magnetic field is almost completely blocked. The ball head adapter on the MagMount Star even comes with it's own cover so that the safety latch is not left swinging around when not in use.

Super Clamp

Depending on the sturdiness of your super clamp, you can hang anything from lighting to smaller odds and ends with these. Super clamps are made to be easy to operate in conjunction with the equipment you use the most. These grip onto surfaces with their jaws and typically

Grip Types

C-CLAMP

CLAMPS

connect with 1/4–20" threading. Manfrotto makes the more popular industrial-strength super clamps, while other third-party companies make similar super clamps that sometimes work just as well. Always check the weight capacity so you will have an idea of what type of payload the clamp will support.

Gaffers Tape

Gaffers tape is made from cloth and should be quickly accessible and easily ripped. Gaffers tape is used on sets for just about anything. Marking equipment, corners, steps and edges, fastening cords, securing equipment, labeling, and everything else in-between that you can possibly imagine; no set should be without gaffers tape. You should look for gaffers tape that is zero residue. This means that there will be no residue left behind on your expensive equipment after the tape is removed. This tape also comes in a variety of colors.

Sandbags

Never underestimate the power of a sandbag. When equipment needs to be steadied in place, sandbags are used to tether it down. Light fixtures especially should be sandbagged. Lights are top-heavy and the light stands they are supported by are thin and easily tippable. To prevent serious injury, broken glass, and damaged equipment, be sure to always sandbag your lights. Beyond securing lighting, sandbags are used for anything else you find needs to be stationed in place.

Velcro Straps

Wires are an inevitable part of a production set. They seem endless and always end up in a tangle. Velcro straps will alleviate this dilemma. These straps are not only reusable and dirt cheap, they also organize the messiest of wiring and can group together small items. I highly recommend having loads of these around to keep your equipment from becoming spaghetti!

The Basics

Getting the Best Results

Lighting & Audio

BASIC TOOLS

89

Shooting Video

Post-production

SANDBAG

VELCRO

Accessories

Cold Shoe Adapter

A hotshoe is an adapter that provides electrical connectivity and communication from your camera to whatever device it is attached to. Found at the top of your DSLR camera, typically used to hold a microphone, light, or flash, a hotshoe is essential for the DSLR shooter. There are coldshoes you can purchase to attach these items when the camera runs out of space. A coldshoe does not provide electrical communication, but will mount your gear just the same.

Lens Care Kit

I keep a lens-care kit in all of my bags, so I always have a means to dust off and wipe down each lens that I'm using. Dust and fingerprints can completely trash a full day's work. Cleaning your lens before each use is a simple step that can save you from a soul-destroying mishap like having to reshoot because your cat's fur was blurring the shots.

Step Up/Down Adapters with Matching Lens Cap Solution

Step-up and step-down adapter rings allow you to have one set of filters that fit to one specifically sized lens. This prevents you from having to purchase multiple filters to fit each of your lenses. Having step up/down adapter rings on hand will give your filters more access to a wider range of your lenses. I also have matching lens caps for each adapter. This keeps everything protected.

Sensor Cleaning

With any method of DSLR self-cleaning you are accepting complete liability for any damage you cause. It's something to be aware of as the sensor is a delicate item and can be damaged by even the gentlest attempt to clean it.

Transportation Types

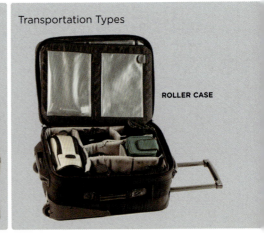

ROLLER CASE

Transportation

Getting your gear from point A to point B is one thing. Hauling it all around in the most efficient way is another. There are two key elements that I consider when packing up for a shoot: mass and how it will be carried. Roller bags and backpacks can both potentially be a pain, but in two very different ways. Rollers take up a free hand, while backpacks can become heavy easily. When shopping for transportation, consider your usual setup and be sure whatever you purchase is modular. You should be able to adapt your bag to what gear you're carrying. Ensure that there is enough padding and separation to absorb shock.

There are bags that come with rain covers, I always recommend that you have this option just in case. Water damage on electrical gear is certain death. Hard cases with foam insulation allow you to pack and not worry about stacking equipment.

Collapsible Utility Wagon

We have a collapsible utility wagon at the studio for easy transportation of the equipment we need to go mobile on shoots. Sometimes it is just a matter of getting armfuls of gear from one side of town to the other. If we don't want to wear backpacks or wheel luggage, the collapsible wagon carts the load for us. It's very useful, easy-to-use, and nicely lightweight.

The Basics

Getting the Best Results

Lighting & Audio

BASIC TOOLS

91

Shooting Video

Post-production

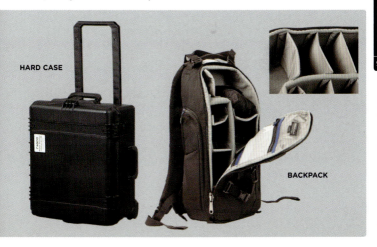

HARD CASE

BACKPACK

Memory

When shooting video on a DSLR camera, one thing is inevitable, you will need to store your data. There are different mediums to store your digital data on. Two of the most commonly used for DSLR shooters are SDHC media and compact flash cards. Memory cards are not made to store long-term data, so the solution to storing mass amounts of digital data over long periods of time are hard drives.

Media cards are compact and re-recordable. They're also absolutely necessary because without these, you can't go shooting any amount of video; you simply won't have anywhere to store your recorded information! A useful tip to remember is that, when dealing with a workflow that requires a lot of memory cards and hard drives, you will want to have an organized system to ensure that all of your footage is accounted for, everything is categorized, and in case anything happens, there is always a backup file. Memory cards come in different sizes, and some argue that you should use several smaller cards as opposed to one very large-capacity card. This could be helpful if the card fails—you will have lost only minimal footage.

CF Card
Compact flash (CF) cards come in varying speeds and can also store different amounts of data. It is important to have more than one CF card as a backup and it's always better than to run out of space and be left with an insufficient supply of storage while on a shoot. Check your

camera's requirements before purchasing media. Most HD video cards that use Compact flash media require a write speed of 133× or faster. If the media is too slow, the camera will have a hard time transferring the data and the video recording will automatically stop. You can always purchase cards that are faster than what you'll require.

SDHC Card
Secure digital cards are smaller and more compact than CF cards. Transfer speeds are rated differently. These also have a variety of data storage capacities and speeds. Smaller cameras generally tend to accept SD cards rather than CF cards. Check to see which style data card your camera uses. Most HD video cameras require at least a Class 6 speed rating (how fast the card can write data) for SDHC media. If your card is too slow for HD video recording, the camera will automatically stop recording after a few seconds. If Class 6 is the minimum required by your camera, you can always get a faster card such as a Class 10. By purchasing a card with a faster read/write speed, your camera should have no trouble writing video files, and it will also help you speed up transferring the files to your computer.

External Hard Drive
An external hard drive is going to quickly become your best friend as you accumulate more and more video content. Backing up your hard work is something that I cannot stress enough. Any video workflow is incomplete without including

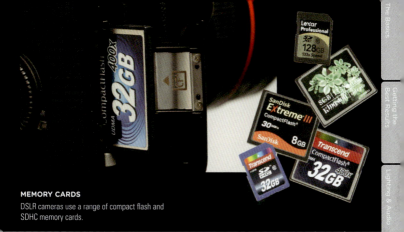

MEMORY CARDS

DSLR cameras use a range of compact flash and SDHC memory cards.

an external hard drive to the process. Think of this as not only relief for your computer, as it won't have to house all of the large video files, but also as your secure video vault. Once you've dumped all of your work onto a master hard drive, you'll always know that it can be found there. Organizing your files is another topic on its own and we'll cover that in-depth later on in the book.

External hard drives come in various speeds and storage capacities. Desktop hard drives are bigger and heavier, while portable drives are made for easy transportation. Depending on the nature of your work and how much data you plan on storing, I always recommend purchasing a larger hard drive. This gives you the capacity to expand before having to purchase a new unit. Also, pay attention to the speed or rate of digital content

transfer, USB technology, and compatibility with your computer. These are key factors when considering purchase.

Card Reader and Card Case

When it comes time to transfer your data from the cards to your computer, a card reader is the best way to go. Card readers are cheap and they accept all types of data cards. A USB connection will transfer all of the card's stored information onto your computer. Some computers can accept media cards, but not all. Having a card reader handy is a way to ensure you will always have a mode of transfer.

Rather than having handfuls of loose cards, a card case is going to organize, hold, and keep your memory cards safe from any damage. I highly recommend picking one of these up, it will make your workflow easier and more organized.

The application of all the basics you have now learned is what shooting video with your DSLR is all about. We are going to take the foundation of all of the information before this section and apply it to going hands-on with your camera and supporting equipment. I will go through pre-production, production, and some post-production to give you a better feel for the process of creating videos.

I will be highlighting some of the common types of video that are shot on a DSLR and covering how you can get the most out of your camera, lenses, and equipment. Whether you will be out in the field in an uncontrolled setting or in a studio with controlled variables, we will cover everything you need to know to start shooting video like a professional.

The case studies we'll look at include a wedding, an electronic news editorial, a video tutorial, a documentary, a feature/short film, and a music video, so there is something for every kind of filmmaker.

Use this section to get clear in your mind what kind of project you want to create, and what you need to do to achieve a successful video. Most importantly, read all of the sections— even if you're an aspiring documentarian, you'll very likely learn something important from the other sections.

SUNNY SAN FRANCISCO
This shoot I produced on San Francisco's Embarcadero was a great lesson in shooting in busy, populated places overlooked by spectators.

Consistent Pre-Production Aspects

The pre-production process is just as important as production and post-production. For every film project that you partake in, there will be a level of planning that is required before the actual video shooting can take place. Making certain that everyone involved in the project is on the same page as regards requirements, scheduling, budget, and the overall goal is a must. Let's touch on a few of the fundamental factors that nearly all video productions must consider during pre-production.

Storyboard

Even for the most simple video tutorials that I shoot, I always storyboard my concept and plan out exactly how I want the information within the video to be presented. When I storyboard my concept of each video, I simply draw out boxes for each scene. Within each box I draw

out ideas of how I want the takes to be framed and composed. I include B-roll, text, and props, to name a few of the elements. Anything that will help in my communication to the director of photography (DP) and the editor to make my ideas translate exactly how I intend them to in the final video must be storyboarded. After I have a solid and completed storyboard drawn out, I write my script.

Script

The script can be optional at times, but in the situations where I need one, it gives me the ability to be precise. Not only are my words very planned out with a script, the timing of the video also falls into the scripting and storyboard. A storyboard can fly under the radar in terms of importance, but I cannot stress enough how much of the workflow is organized by just adding

STORYBOARDS
When planning your videos, a detailed storyboard will save you a lot of time when it comes to both filming and editing.

this one piece to the pre-production process. I use Google Docs to keep and organize all of my scripts. This way, the director of photography and the editor can look over it in real time and changes can be made to one live document. I organize simple web video scripts in Google Excel Docs. Another benefit of keeping my scripts in Google Docs is that, because they live in the cloud, they can be accessed from anyone they are shared with at anytime, anywhere. Cloud-based documents cannot easily be deleted or lost.

Casting

Good casting is crucial! This not only applies to the casting of actors that needs to take place for a film, it also has to do with the casting of your production crew. If there is one thing I've learned from working on different sets and productions,

it is that properly casting your support team is everything. The talent in front of and behind the camera determines the final outcome of your project. Take into consideration schedules, outside projects, relations, and experience. Cast your crew according, not only the level of their skills and experience, but also to schedules and reliability. There is no right or wrong way of doing this. The one rule that I always stick to in order to avoid confusion and miscommunication is to make very clear what each person's specific role is.

As long as your crew knows exactly what they are individually responsible for, they can stick to what they are best fit to do. I have come to find that if someone is left without a very specific role, miscommunication begins to complicate the workflow. Avoiding this will prevent unneccessary frustration down the line.

COMMUNICATION

Make sure everyone on-set is absolutely aware of their role in the production. Nothing causes a shoot to descend into chaos quicker than confusion.

The Basics

Getting the Best Results

Lighting & Audio

Basic Tools

SHOOTING VIDEO

97

Post-production

Scouting & Permits

Once you have your storyboard, script, and cast resolved, scouting before the actual shoot is highly advised. There have been instances when my crew and I have gone out on a shoot and completely neglected to scout, since we had all been there at one point in the past. This can be a recipe for disaster. There are two scenarios where a situation like this can go south: controlled settings and uncontrolled settings. In a controlled setting, if you don't scout out the environment for time, light, sound, and permission, you could run into problems in one or all of those areas. In an uncontrolled setting, copy and paste the factors from above. What I'm getting at here is that by skipping scouting and permission to shoot, you run a very high risk of wasting an entire day of shooting. In an uncontrolled setting such as an outdoor shoot, always remember to check the weather and light conditions. I produced a shoot that took place on San Francisco's Embarcadero, and prior to the scheduled shoot day, I went to the location at the

SCOUTING LOCATIONS

Knowing the layout of the location helped enormously on this shoot, as I knew exactly where we'd get the best shots. Note how the looming background buildings frame our dancer.

Example Checklist

Pre-production
- Pre-production meeting with input from all creative teams
- Location and scene selection
- Review of location and scene selection
- Talent casting
- Talent review and feedback
- Confirm and book talent
- Storyboard script
- Review storyboard and script
- Book film crew (producer, DP, PA, grip etc.)
- Buy or rent equipment
- Equipment assembly
- Location preparation

Production & Post-production
- Setup
- Shooting
- File preparation
- Editing
- Creating social media videos
- Review video
- Overall creative review of project

Final Review to Final Delivery
- Incorporate feedback from video and creative reviews
- Create final video
- Deliver final video in required format(s)

The Basics

Getting the Best Results

Lighting & Audio

Basic Tools

SHOOTING VIDEO

99

Post-production

actual time of the future shoot to test the lighting. Buildings block the sun after 5:00 P.M. in that particular location for that time of the year. Had I not known this, we could have lost crucial light and would have been left with insufficient footage, forcing us into a second day of shooting. I also needed to make certain that we had clearance to film on public property in that location. If you are caught filming without a proper permit, you could be fined and will definitely be asked to pack up and leave. To avoid these simple mistakes, scouting and acquiring the proper permission is essential. In some areas you can film, just so long as it is not on a tripod. Be sure to double-check these minor laws so you can create the proper checklist for the shoot.

Checklist
Once you've completed all of the above vitals and your team is ready to shoot, you should always create and complete a checklist. Checklists will vary depending on what type of production you are involved in. They can cover everything from contracts to release forms, licenses, nearest hospitals, crew members, and authorization forms. The checklists I normally create for smaller location shoots consist of equipment along with the number of each piece of equipment needed, check boxes to indicate fully charged batteries, backups, water, and any wardrobe and make-up needed. Checklists are going to vary. It is convenient to have a standard template to go by so you are familiar with the format of your checklist.

Production

Gathering Footage

The supporting footage for a video is also called B-roll. Your cutaways can consist of B-roll as well. Usually, there is a dedicated B camera for shooting additional video that will be cut into the main A camera-footage to assist in telling the story.

B-Roll B-roll footage assists with creating a visually interesting piece and helps to convey more information into the story. Oftentimes a voiceover track will go over the B-roll. A straightforward interview or presentation of information can become boring very quickly. B-roll keeps the video moving, introduces visual support and gives the overall video more dynamic impact. B-roll can also be used to cover up any footage that you don't want to be shown.

Cutaway When the continuous film is interrupted and supporting footage or B-roll is inserted, this is a cutaway. It is the job of the video editor to avoid jump cuts when inserting cutaways. A jump cut is essentially the same shot, but cut together in such a way that shows a slight shift in continuity. Jump cuts are bad practice and should be avoided.

Signage One important B-roll shot that can go overlooked is signage. Let's say you are shooting an editorial piece on a clothing company. Your B-roll will include shots of the store's interior, the clothes, and possible customer transactions, as all of these things happen within the store. An important shot that I've seen forgotten more times than one is the business sign on the outside of the building. Establishing where you are taking the viewer and what is being shown cannot be left out. A sign, the company's logo, the street the business is on—all of these things add context to the entire piece. When you storyboard, these shots should be included to be certain that they are not accidentally left out.

B-ROLL

Set the scene and provide further exposition to your story with B-roll shots.

SIGNAGE

Always capture some signage shots to help establish the location of your story.

CUTAWAY

Capture additional shots from around the location that can be edited into your sequences. They are useful when you need to cover a jump in the main coverage.

01:00:05:11 01:00:05:24

01:00:05:11 01:00:05:24

CUTAWAY

Basics

Getting the
Best Results

Lighting & Audio

Basic Tools

SHOOTING
VIDEO

101

Post-production

Types of Video: Event

Within shooting videos on your DSLR, there are different types of video that you can explore your talents and creativity with. The main types I will be touching on are event, editorial, narrative, documentary, music video and tutorial. We will dive into different shooting aspects of each type of video. Some techniques and practices will carry on for a variety of video types, so I encourage you to read through all of the content. Aside from reading, going out and shooting video on your own will give you the experience you need to hone your skills and gain a deeper understanding of videography.

Videos classified under events tend to be "capture the moment" types of situations. You as the videographer are documenting the event and telling a story with the footage through highlights and information. For event shooting, before you jump right in and start gathering footage, knowing the itinerary can really help to plan out your execution process. I will focus on a wedding and detail how to prepare and shoot for one.

CAPTURING A MOMENT

Case Study 1: Wedding

When shooting a wedding there are permanent factors that you must take into consideration. With a wedding, you will rarely ever get a second chance to get your shot. Things happen fast and you must be prepared to work efficiently with the tools you have and what is available within your surroundings. Bringing too much equipment can easily become a burden and not bringing enough, or the most efficient gear, can leave you under-prepared. I'm going suggest a few common professional tools that will keep you mobile and ensure a smooth workflow. We will cover how to properly apply the equipment listed to capture the best results with the correct camera settings.

Pre-Production

Learn the itinerary. Coordinate with teammates as to who will be covering what. Communication is your strongest ally at a wedding. Know the day's schedule. Not only will the wedding itself need to be shot, the process of getting ready on both the bride and the groom's side of the story must be covered. Plan ahead with the family so you will not miss any of the entire day's events. There are key aspects to a wedding day that every couple wants to see. Getting ready, clothing, emotions, walking down the aisle, exchanging of vows, the first kiss as a married couple, the first dance: be sure to create a list of the shots you do not want to miss and plan ahead to ensure these shots are covered. Do you have a contract? Although this has nothing to do with your DSLR, it is something to consider before going into a job like this.

Camera Settings

Be sure everyone on your team has their camera on the same settings in order to keep consistency in the final video. Multiple angles mean multiple cameras. If each camera has a different color temperature or picture profile setting, the look of the video is not going to remain consistent. Too much variation in the shots can become distracting from the story you are trying to tell and the final video will suffer.

Shutter Speed

If you are shooting outdoors, and you are trying to achieve a filmlike look with a shallow depth of field, I cannot stress enough the importance of having an ND filter on you at all times. If your lens has a beautiful 1.7 capable aperture, this is going to do nothing for you if you cannot maintain your shutter speed. With the introduction of an ND filter, you can stop down the light and remain wide open even in broad daylight. To keep the cinematic look of video on a DSLR, you must remain at a 1/50th second shutter speed when shooting at 25p, 1/48th second shutter speed when shooting at 24p or 1/60th second if shooting at 30p. An ND filter will allow you to keep your shutter at a consistent speed.

TIP: A variable ND filter will allow you to dial in different densities without changing filters. This gives you more speed in fast-moving situations and lessens your load.

BE PREPARED
Visit each location ahead of the event and decide on the best angles—then all you need to worry about on the day is capturing them.

TAKE TOOLS YOU ARE FAMILIAR WITH

HAVE YOUR CAMERA ON THE SAME TEAM SETTING

KNOW THE DAY'S SCHEDULE

The Basics

Getting the Best Results

Lighting & Audio

Basic Tools

SHOOTING VIDEO

103

Post-production

White Balance

This important step is somehow often overlooked when in a hurry. The auto white balance feature in your camera does a pretty good job, but when you are moving around, the colors can shift very quickly. You should practice setting the white balance manually in your camera according to your environment. If it is cloudy outside, set your white balance to cloudy or dial in the Kelvin temperature you see fit. With practice you should be able to adjust the white balance through the Manual Kelvin setting dialing in the exact white balance temperature. You also want to be sure to communicate this to the other camera operators so the temperature remains consistent. If you are in mixed lighting, it is very important to manually dial in the white balance in your camera. Do not use auto white balance. The color in your video will shift as the light changes to compensate and it will look very jumpy and unprofessional.

ISO

Your ISO should be set low for outdoor shooting: 100 to 160, and a higher ISO should be set for low-light shooting. Avoid going higher than 1600, otherwise you could introduce grain to your shots. A fast (wide aperture) lens will help you shoot in low-light settings so you can keep the ISO low. Prime lenses with a maximum aperture of $f/1.2$–$f/2.8$ are perfect for these types of situations.

Aperture

Aside from the gorgeous shallow depth of field you'll get from an aperture that is really wide open, being able to shoot at a $f/1.8$ or lower means that you can capture low-light situations. At weddings, bringing large additional lighting should never be an option. The only exception is if you have worked this out with the wedding party beforehand. There is no place for large intrusive lights at either the ceremony or reception where the ambient lighting has been set specifically for the mood of the event. Most weddings

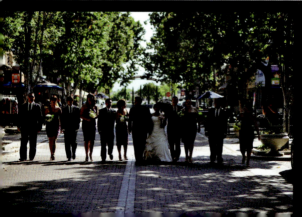

KEY GROUP SHOTS

Gather groups of people together and choreograph some simple walking and talking scenes.

pay extra fees to have a specific look and feel to their reception. It is your job to work without being a distraction. The images will also look more natural when shot in the available lighting and translate the mood of the environment into your final video. For this, you will need a lens that is capable of an aperture of at least 1.8 or below. A fast lens that is able to shoot this wide open will allow more light in and, ultimately, determine whether or not it is capable of shooting in low lighting.

Lenses

Capturing steady footage is important and a lens with image stabilization can make a world of difference. Image stabilization is not necessary when the camera is used on a tripod, but whenever possible, you should always consider lenses with image stabilization. Besides going for IS lenses, you must also consider focal length and what type of situations you will be presented with at the wedding.

When getting close to the action is not an option, a zoom lens will allow you to do so from afar. A great go-to zoom lens that will give you a nice range of focal lengths is a 70–200mm. Cropped sensor cameras naturally multiply focal lengths, and will have an advantage when you need to shoot from a distance. For your close and medium shots, the fool-proof "nifty fifty" 50mm prime lens is a safe bet. The 50mm is offered in $f/1.2$, $f/1.4$, and $f/1.8$ (cheapest). It is going to give you most of the standard shots that mimic what the human eye sees and that will allow you to take advantage of a shallow depth of field— what DSLR video is most known for. An 85mm lens will get in closer for more intimate shots while you keep a safe distance. Both of these lenses are highly versatile and can be used for action, portraits, and low lighting, as long as the aperture is capable of at least $f/1.8$.

CAPTURING THE MOMENT

Being in the right place at the right time is crucial—make a schedule and stick to it.

The Basics

Getting the Best Results

Lighting & Audio

Basic Tools

SHOOTING VIDEO

105

Post-production

Keep in mind that some lenses have a limitation with a "minimum focusing distance" and will require you to be several feet away in order for the lens to properly focus. If you're shooting in a small space, look for lenses that can focus within a few feet. Shooting at an aperture of $f/2.8–f/5.6$ will keep your subject in focus and slightly blur out the background. This will also give you a wider range of focus field to work with so that things don't fall out of focus and get soft each time they move by a few inches. When shooting the preparation prior to the actual ceremony, the 50mm and the 85mm are perfect for tight shots. However, a wide lens will be needed to show more. Your wide lenses, like a 24mm or a 35mm, will be just wide enough to capture shots spanning large areas. Anything much wider than a 24mm may begin to get distortion, which is not always flattering with portraits. In some cases, it can be used to give a very nice stylized look.

Always take crop factor into consideration. Know your lenses and your camera. Focal distance is also a factor you need to consider. If your lens can only achieve focus from 6 feet away, it will be much more difficult to shoot on the fly than if you can focus in from 2 feet to infinity. Having a broader focusing range gives you more area and, ultimately, more versatility to shoot within.

Monopod

A monopod is the wedding shooter's best friend. Weddings happen fast, the shots are fleeting, so speed and accuracy are important. A monopod will give you the ability to move, setup and shoot at lightning speeds. Carbon fiber monopods are lighter than aluminum and will add less weight to your overall payload. Be mindful of how the monopod locks each telescoping section. Typically, you will either have lever locks or twisting lock features.

CAPTURE DETAILS

Don't just capture the events as they unfold, look for other creative shots that you can use in your video.

The Basics

Getting the Best Results

Lighting & Audio

Basic Tools

SHOOTING VIDEO

107

Post-production

Sliders

First begin with taking into consideration the situations that you will be confined to. Small spaces like hotel rooms or dance floors will require more compact setups. Camera sliders that are no longer than 4 feet in length will allow you to have stable creativity in your shots, while still keeping your setup to the bare minimum. Slider-style shots are popular because they always look amazing.

Stabilizer

Small handheld stabilizers like the Steadicam Merlin or Glidecam HD1000 will allow you to achieve smooth dynamic camera movements, and, they take up minimal space in your equipment bag. A wide lens allows you to capture the action and put more of the image in focus as you move.

If you're planning to shoot flying camera footage for more than a few minutes, you may want to invest in a vest support system. Flying a camera stabilizer can be tiring, so a vest support with articulating arm will allow you to carry the stabilizer for a longer period of time, and also help to carry heavier flying stabilizer setups.

Tripod

Tripods should be used in slower-paced portions of the wedding like the ceremony or reception, when you can maintain a static position. Keeping your camera mounted to a DSLR cage with handles will allow you to quickly dismount for stabilized handheld shots.

OUTDOOR SHOTS

Outdoor shots need to be planned well in advance so you know the best time of day, location, and angle to get your footage from.

Audio

If you are shooting a wedding that requires audio, planning which pieces of audio gear to bring is essential. What type of audio will you be capturing? For vows, speeches, and testimonials there are multiple types of microphone setups. Wireless microphones and receivers that feed into an external recording device will capture the audio clearly. A drawback to this type of setup, however, is having to plan ahead to properly mic up the necessary people prior to the action. Another alternative is using a wired lavalier mic that connects to a small external recording device like a Zoom H1. This device can easily be hidden in the pocket of the groom and officiant. Having the bride wear a lav microphone is normally not an option. For this reason, you want your lavalier microphones to be omnidirectional so you can pick up the bride's voice with the groom and officiant's microphone.

Memory

You must be sure that you bring a sufficient number of memory cards for the duration of your shooting time. It is safe to estimate 3 minutes of 1080p 24fps video on a DSLR is going to take up approximately 1 gigabyte of memory. Calculate the time you will be shooting and allow yourself a safety cushion, then plan and provide your memory cards accordingly. I always suggest adding extra cards just in case one fails. Once you know how many cards you will need you can then multiply that by the number of cameras your team will be shooting with to find your grand total of memory cards. Proper organization of the cards and cameras will help your post-production workflow and ensure that no footage is lost. A simple way to do this is by labeling each camera by number and all of the memory cards associated with that specific camera by the same numbers. You can even label your cards in chronological order per camera to be even more detailed (A-1, A-2, A-3, etc.).

KEY MOMENTS

Make sure you have enough memory and do not run out at a crucial moment—reshoots at weddings tend to annoy the guests and ruin the spontaneity.

108

DSLR video cameras are not capable of long video clips. Keep this in mind when recording long speeches or ceremonial activities. Currently, DSLR-type video cameras can only capture a limited amount of time per video clip. For cameras not classified as "video cameras," there are certain laws limiting their recording time to under 30 minutes for each clip. If you're shooting compact flash and SDHC media, the file size limitation is about 4GB and may cause the camera to stop recording when the file limit is reached. This may translate to about 12 minutes of HD high-resolution video for each clip.

> TIP: Some video shooters will tell you to keep the card capacity small so that in case of media failure, you won't have lost all the footage. Using smaller-capacity cards will mean swapping out cards more frequently. This is a matter of preference.

Editing the Footage

If you are editing a wedding video to a song, be sure to let the client know that once the song is chosen for the video, changing the song track is next to impossible. Unless you want to re-edit the entire video, your best bet is to confirm a song choice and stick to it.

B-ROLL FOOTAGE

Set the scene and provide further exposition to your story with B-roll shots.

The Basics

Getting the Best Results

Lighting & Audio

Basic Tools

SHOOTING VIDEO

109

Post-production

Types of Video: Editorial

Within types of video, editorials are more commonly known as informational. Editorials are factual pieces that provide the viewer with information supported by interviews, research and gathering of footage. We will take a look into electronic news gathering (ENG) and tutorials shot for the web. Both of these contain principles and elements that can be applied to a wide range of other types of shooting. I want to cover planning, gear, and execution.

Case Study 2
Electronic News Gathering (ENG)

Event Camera Rig
Due to the ergonomics of the small compact body style of DSLR cameras, a rig is going to give you more support, a steadied hand and mounting points for the equipment needed in field shooting.

Electronic Viewfinder
Shooting in bright daylight, it is difficult for the camera operator to clearly see what aspects of the shot are in focus. A field monitor with a loupe will block out all unwanted light and magnify the image on the LCD monitor. This technique is used to ensure correct exposure and focus.

Cinevate Follow Focus

A follow focus will make it easier for the camera operator to focus in on the focal points of the shot. DSLR cameras do not have ideal ergonomics for shooting video. When using a rig and setup like this especially, a follow focus makes focus much easier to achieve.

Shotgun Microphone

As a second audio source, the shotgun microphone is mounted on the hotshoe of the camera. If this is your only source for external audio capture outside of the built-in mic on the DSLR, it is better than nothing. We are using this as a backup in case any of the other audio fails and to pick up the audio for easier syncing in post.

Matte Box

The matte box we have around the camera's lens is used to block out any light that would otherwise cause a lens flare. When harsh sun or bright lights hit the camera lens, a noticeable flare occurs. This can be prevented with a matte box.

Friction Arm

The photography and cinema friction arm we are using in this configuration is holding up the small HD monitor and EVF. Friction arms can be used on just about any piece of equipment and articulated in a wide range of orientations.

KNOW YOUR CREW

Work with a crew you trust to deliver high-quality work. Professionalism, organization, and trust are all paramount.

EVENT CAMERA RIG

ELECTRONIC VIEWFINDER

CINEVATE FOLLOW FOCUS

The Basics

Getting the Best Results

Lighting & Audio

Basic Tools

SHOOTING VIDEO

111

Post-production

Audio

The field mixer being used maximizes our number of XLR microphone inputs. The field mixer also produces the best-quality sound possible while in the field. An external audio recorder like the Zoom H4N produces high-quality audio, but the level at which you can fine-tune your audio is very minimal.

A field mixer allows the operator to monitor all sounds coming in and keep them at desired levels.

A boom pole by PCS is how the audio is captured while I'm outdoors and on location. A boom operator listens to the audio coming in and positions the microphone at an optimal orientation to pick up my voice. The operator wants to bring the microphone as close to me or the subject being interviewed to get the best signal-to-noise ratio.

The Rode VideoMic Pro is a shotgun microphone and is being used because it has a very directional pick-up pattern. This type of polar pattern will hone

ADDITIONAL SOUNDS

After completing all your interviews, gather a range of atmospheric tracks from the location. These can be used to smooth over edit points in your video's soundtrack.

MICROPHONE POSITIONING

Position the microphone as close as possible to improve the signal-to-noise ratio.

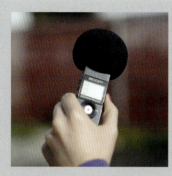

HAND MIC

The hand mic is an indispensable piece of equipment for use in the field.

in on my voice and since it is being pointed down, the microphone will only pick my voice up and will reject sounds coming in from the sides. Headphones allow the operator to monitor the sound.

Windscreen

A windscreen will cut unwanted wind noise out of the audio. Hissing and rumble can be introduced if the conditions outside are very windy, and a windscreen is used to prevent this. We could also have a blimp for even greater resistance against wind.

Lighting

A simple reflector is being used as a light source. We are shooting with my back against the sun to avoid harsh shadows from its direct light and the subject (me) squinting into the camera. Since my back is completely lit up by the light source, we now use the reflector to bounce the sun's light back onto my face for correct exposure and proper lighting.

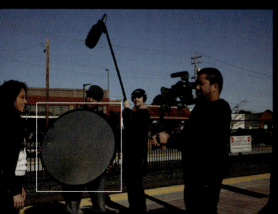

REFLECTOR

Use a bounce reflector to illuminate your presenter's face and to improve exposure levels.

ENG in compact spaces

Tripod: Manfrotto 501 Video Fluid Head
A tripod is an absolute necessity when shooting ENG-style video with your DSLR. A tripod will faithfully provide a steady anchor to support your setup. As long as you have a video fluid head on the tripod, you will be able to capture smooth panning and tilting.

Additional Gear
The Varavon cage provides the camera operator with mounting points for the equipment being used. A cage on a quick-release plate also allows the shooter to move the entire setup very easily without having to take the gear apart and reconfigure. The Varavon Profinder is a loupe and provides the camera operator with an eyepiece to use for accurate focus and exposure. This particular model also allows you to flip the eyepiece out and uses a mirror to reflect the camera's LCD screen. This way you can take low-to-the-ground shots and still see your LCD.

Lighting
The large LED 900 panel we are using is being battery powered by a Tekkeon MyPower portable battery pack. We are using the LED light, since there is not enough light in the dark bus stop we are shooting in. This is the fill light. The LED 900 is on a light stand. The 312 Dual Color LED light on the 5D Mark II's hotshoe is acting as a key light.

CAGE WITH HANDGRIP

This cage has a useful handgrip. With a handgrip on the top of your DSLR you can capture shots low to the ground or in other tight spaces much more easily.

Audio

We are recording the audio onto the Zoom H4N. This external recording device is what records and stores all of the audio media for the ENG gathering.

Sennheiser's Evolution G2 Wireless Microphone and Receiver is picking up my audio through a lavalier microphone. The receiver's XLR output is plugged into the Zoom H4N input.

We are using a second shotgun microphone that is also plugged into the Zoom H4N through an XLR cable.

The shotgun microphone is mounted in a shock mount on a pistol grip. In the small space, a boom pole is too large, so a pistol grip is being used instead. If we were interviewing a subject, the shotgun mic would be used to pick up their voice. The operator holds the microphone out of the camera's view and as close to the subject as possible.

The audio operator is monitoring all of the audio through headphones.

> **TIP:** When capturing footage for news stories, always remember to pan and tilt very slowly. You want to allow at least 10 seconds for each setup of a static shot, pan or tilt very slowly and on the end point allow another 10 seconds to lapse before you end the recording.

THE VARAVON PROFINDER

The Profinder is Varavon's low-angle LCD viewfinder compatible with Canon's 5D Mark II, but can be used with or without the accompanying Varavon camera cage.

Types of Video: Tutorial

In short, a tutorial is a step-by-step instructional on how to do something. Tutorials have to be precise and very clear so that the viewer can easily understand all of the information you are conveying to them. Supporting B-roll and beauty shots add to the production value and overall dynamic of the learning experience for the viewer. People watch tutorial videos for one reason: to learn something. That is your main goal, to accurately teach your audience what your tutorial is focused on. Once all of the pertinent information is packed into the tutorial's content, then you can get creative and inject the fun. Always stay on track with the topic at hand and be aware of your audience.

Case Study 3: Tutorial

Pre-production
I have to repeat this: when you are shooting a tutorial-style video, your main objective is to convey information in a clear and easy-to-understand way. Too often people go off-topic and become long-winded during a tutorial video. The viewer typically only wants to learn; if the information and content is good, they are more likely to stay for any added entertainment or humor. Supporting visuals help to give your audience a deeper understanding beyond the script. You can even cut the script down if needed and suffice with visual support. By storyboarding your segment, you can see how your video will be shot and pieced together. This method is a way of organizing your shot list so it correlates with the script.

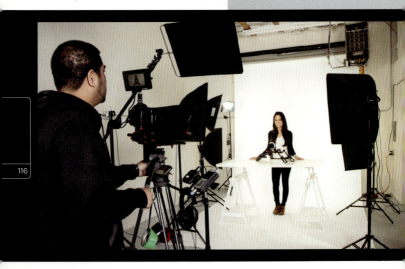

Gathering Footage

For a tutorial, your B-roll footage is immensely important. You want to be sure that your audience sees a very clear depiction of what it is that you are talking about. The supporting shots are going to add a highly produced value to your video and will keep your audience engaged. For this, you'll want to go by the script so that you have a solid guideline of what it is that you need to gather footage of.

For the OliviaTech tutorials shot in-studio, I'll list the gear shown and we'll go over the functions and usage of each.

Camera & Rig

Canon 5D Mark II and Gini Rail System: This rail system allows us to mount all of the gear, along with the camera, onto the tripod. An industry-standard set of 15mm rods and clamps can be configured together to hold multiple pieces of equipment at once.

SIMPLICITY

For tutorial videos, keep your setup, lighting, and background simple and clean.

TIP: Having a macro lens for beauty shots really adds to the dynamic of a tutorial video. Highly detailed close-up shots with a macro make for beautiful video footage and bring out qualities that other lenses can't always capture.

External Monitor

A smallHD Dp4: An external monitor like the smallHD gives the camera operator a larger LCD screen to look at. When there is a director and a camera operator, an external monitor acts as a second source to watch the video and playback from.

Support

Tripod (bowl mount), Libec LS22, Head H22 DV, Legs T58, Light Stand, ePhoto Stabilizing: Tutorials that have stand-up presentation footage of a talking host are best shot on a tripod. This, of course, depends on your video's style and whether or not your environment allows for this type of setup. For in-studio shoots, tripod shots give a clean and steady shot. Less camera shake gives more attention to the actual information and equates to less distraction for the viewer. For the tutorial videos we shoot in the studio against an infinite white backdrop, we always use a tripod. For in-studio shoots, tripod shots give a clean and steady shot. Less camera shake gives more attention to the actual information and equates to less distraction for the viewer.

Lenses

Canon 24–105mm and Canon 70–200mm: We typically shoot the OliviaTech tutorials with a Canon 70–200mm lens, since it shoots a more narrow field of view. This means we won't have to deal with cropping out the lights later on in post-production. The background's Savage seamless white paper is 9 feet wide and the camera is approximately 20 feet away. For the size of our studio, a zoom lens with an aperture of $f/4$ is sufficient, since we are controlling the light. We will always have an ideal amount of light to work with and therefore we can keep the ISO high.

Lighting

CFL softbox lighting (6), Lowell Omni hotlight, color temperature blue gel, flag: The CFL softboxes are used to light the backdrop and two are used as a key and fill to light the subject, me. We use a Lowell Omni hotlight as a rim light. Here, we threw a CTB gel on the hotlight since the color temperature of it is tungsten. In order to match for the daylight temperature of the CFL lights, a CTB gel corrects the color so we do not get mixed light. If you have mixed light, it is much more difficult to work with the white backdrop in post-processing.

Audio

Zoom H4N to record audio, Sennheiser's Evolution G2 Wireless Microphone and Receiver, headphones to monitor the quality of sound: The audio aspect of video is half of the entire experience. For this reason, capturing optimal audio is crucial. If you have a terrific tutorial chalked with excellent information, it will all be in vain if the audio is poorly captured. Depending on your crew and environment, there are different setups that will give you the best-sounding audio possible. As a general rule of thumb, you want to avoid using the built-in microphone on your DSLR at all costs. If you're looking to record directly into the camera so you don't have to sync your audio in post, you should always use a preamp to get the best signal-to-noise ratio. If you plan to use an external audio recorder only or in conjunction with microphones, getting the mic as close to your subject as possible is key. Whether you are using a wired or a wireless mic system with microphones and receivers, keeping the external audio recorder on a separate stand is typically your best bet. It can be monitored away from the camera and has less of a chance to interfere with the camera's actual recording. Attaching your external microphone receivers to a cage would be your second best option. If you are using your external recorder only to capture audio, you want to either boom it as close to the subject as possible, or if you must keep the recorder on your camera's setup, keep in mind that the audio recorder can pickup and electronic noise coming from the camera itself. This includes lens image-stabilization noise.

Teleprompter

When shooting tutorials or scripted editorials where a host needs to be fully engaged with the viewers, a teleprompter can be used. A teleprompter (sometimes called a prompter) uses a glass beam splitter (mirrorlike) placed in front of the camera's lens at an angle to reflect an image or screen with

TELEPROMPTER SIDE VIEW **TELEPROMPTER**

scrolling words. The angle of the beam splitter allows the camera to see through the back of it without detecting any of the reflected image from the outside.

The teleprompter is designed for the on-screen talent to read off a script, while keeping focus directly into the camera's lens. Reading cards placed very close to the camera will not be as effective, as you can easily detect when the talent is shifting their eyes to read. Teleprompters are shrinking in price and size, while growing in popularity. These units re making it easier for both field and studio shooters to minimize unusable takes. The teleprompter I use in the studio is a lifesaver for my OliviaTech video reviews. The benefit of using a teleprompter is that you can deliver lines effortlessly and edit as you go. There are also many teleprompter apps available for iPad and iPhone, such as PadPrompter and ProPrompter.

Teleprompters help by saving time on unusable takes and in the post-production workflow. They are commonly used in professional studios and can run to up a few thousand dollars. With the iPad, there are apps and devices that allow you to go mobile with a teleprompter by connecting it to any industry-standard 15mm rod system. Some apps even allow you to remote in via an iPhone like the one we use, ProPrompter. The options and do-it-yourself solutions are growing, making a teleprompter easy to acquire.

Grip

Gaffers tape, sandbags, mounting plate, magnetic quick-release adapters, shark clip, extension cords, power squid: We use gaffers tape for just about everything in the studio. Most commonly, we tape down cords so no one trips while walking about the studio space and I use it to mark my place in front of the camera so the camera and lighting can remain in their fixed positions. Sandbags keep the lights from tipping over and the seamless paper from curling up and moving out of place. We have a basic mounting plate to keep all of the audio equipment on one light stand. As a quick-release solution so we don't have to unscrew all of the equipment each time we move our setup, magnetic QR adapters are mounted on most of the gear we use everyday. A shark clip is used to articulate the iPhone so it can used while shooting.

Backdrop

Savage seamless white paper, Backdrop roller changer: Field vs Studio. Sometimes we shoot tutorial videos in the field in uncontrolled settings. Planning in advance for these types of shoots is important, as this process gives you the foresight to properly gear-up for the situation you will be in. If you are shooting outdoors on location, the gear you bring with you will be different from what a studio shoot requires. For field shoots, ease of transportation and necessary equipment is important. I create a checklist for our field tutorial shoots that look much like ENG-style shoots. This includes a rig, audio, memory cards, lenses, and oftentimes an EVF.

SEAMLESS WHITE BACKDROP

The Basics

Getting the Best Results

Lighting & Audio

Basic Tools

SHOOTING VIDEO

119

Post-production

Types of Video: Documentary

What qualifies a film to be a documentary? By textbook standards, this would be a nonfiction film that aims to document an aspect of reality. Documentaries usually give the audience in-depth perspective and information that they may not have been exposed to otherwise. Documentaries range from short to full-length and can be categorized as anything from experimental, historical, a portrait, or investigative.

PLANNING, GEAR, & EXECUTION

As documentaries rely so much on the schedules of others—interviewees, for example—you need to be even more organized. Have all of your equipment efficiently packed, know where you're going and when, and make sure all of your crew are on the same page.

Case Study 4: Documentary

Documentary
Documentaries are unique in that there are no real rules behind making a documentary-style film. The director's artistic approach is purely based on the way they choose to tell the story and that's what is oftentimes so exciting about making a documentary. There is tons of potential behind the creation process, as the standard limitations can be pressed as far as the director is willing to go.

Pre-Production
Filming a documentary requires you to venture out in the field. In order to capture footage that will support the story you wish to relay to your audience, you must first plan accordingly. From what I've experienced, no amount of planning can ever prepare you 100% for documentary shoots. You are often working with the schedules of other people when wrangling interviews and the number of changing variables that you will encounter will

be many. For this reason, pre-production is a must, but equally important is to pack appropriately so you can be best-equipped for any situation.

Whether or not a producer is coordinating all of the pre-production tasks, as the shooter, packing everything you will need for dynamic situations will ensure that you are always prepared. I'll touch on the pre-production very lightly, then go right into production.

Research

I will only touch on this aspect of making a documentary very briefly. The research needed prior to shooting a documentary is absolutely key in the final outcome and story structure. After you have a concept for a documentary film, you must then go out and do all of the research that will support your storyline. This means investigating the history behind the story, gathering facts and opinions, and learning everything revolving around the topic that you are focusing on. This information will often help to direct you to where you need to shoot and whom you need to interview.

Scouting, Permission, & Shoot Planning

Once the concept is drawn up and a game plan is intact, scout out the shooting locations. Obtain all necessary permits, prepare and print plenty of release forms, and line up the interviews that will play a role in telling the story. All of the background research will pay off and make the shooting process more streamline. Also, remember to give yourself extra time. When setting up shoots and interviews with people, there is a process of research, contact, waiting for a response, the usual back and forth of coordinating time frames and so on. Keep a calendar and stay on top of the organizational aspect. Don't forget to prepare and have release forms on you at all times.

THERE WILL BE MANY CHANGING VARIABLES

RESEARCH IS KEY TO THE FINAL OUTCOME

SCOUT SHOOTING LOCATIONS

The Basics

Getting the Best Results

Lighting & Audio

Basic Tools

SHOOTING VIDEO

121

Post-production

Setup

The gear that you outfit your camera setup with will all contribute to ease of traveling. Every situation is going to be different, so each setup will depend on the environment.

Rig

Consider the environment and location of your shoot. If you are allowed clearance of a rig setup for the location, it will serve to hold any necessary equipment you need to support your shoot. If the location is unfamiliar, high in crime or in a general area where attracting too much attention could result in bringing the production to a halt, use alternatives like a tripod or go handheld.

If you are filming your main scenes and B-roll footage, take into account the order that you should be shooting all of the footage.

Equipment checklist:

- Camera with a lens or multiple lenses
- Cage
- ND and/or polarizing filters
- Audio: External recording device, shotgun microphone, wireless microphone(s) and receiver(s)
- Lighting: Portable on-camera LED light
- Viewfinder

The question is always this, what do you absolutely need? Again, documentaries will vary in budget and environment. Take into account the overall weight of your load, the transportation process and the environment. Then, pack accordingly. You don't want to get robbed or be stuck traveling long and far distances with an excess of unneeded gear.

B-ROLL

If conditions for filmmaking are not ideal, then when you're in one setup try to capture all the B-roll you can then and there, as you might not be able to record later

CHOOSING EQUIPMENT

If you know you're working in a confined indoor space, you should select your shooting equipment to reflect this.

Camera Cage

Mounting your camera onto a cage while on location for a documentary shoot can help you in a number of ways. First, the cage is going to lessen the shakiness of handheld shots. Multiple mounting points on the cage also will serve as areas that you can utilize for the gear you will be using, even when running and gunning with just the essentials, i.e.: shotgun microphone, external recording device and an LED light. Another benefit to using a cage is that with a quick-release plate, you can go from handheld to a tripod setup very easily and fast. With all of your gear already mounted to the cage, you don't need to worry about collecting your equipment as you change setups, as everything goes with your camera and cage.

Tripod or Monopod?

If you want to really scale down or increase your mobility, a monopod with a video fluid head is your best bet. This will ensure you get steady shots when you need them and a lightweight monopod can be carried very easily. Carbon fiber is an ultra light material and is oftentimes preferred over aluminum for traveling.

Lighting

What will your situation allow? Portable lighting is your best bet for this documentary-style shooting. On-camera LED lights like the 312 Dual Color LEDs are lightweight and can sit directly on top of your camera. Portable LED lights like the LED 900 can be battery powered by a pack like the Tekkeon. The only issue with this is the extra load and the attention larger setups will draw. If you can make use of the available light, a reflector can really make the most of the available sun source. These require no external power source, only the sun, and are very compact and easy to carry. The downside again here is the attention factor. Reflectors tend to draw attention and if this is something you don't want while shooting, you are best off using the available light only.

Audio

An external recording device will allow you to either record directly into the equipment as a microphone or plug multiple microphones in. These are wonderful audio solutions as they're light, reliable, and they do not draw any battery power from or interfere with the camera. Always be sure to have a pair of headphones to monitor the audio with.

Shotgun Mic with Windscreen:
Rode VideoMic Pro

With a shotgun microphone, you can get in close to your subject to capture the best sound possible. The downside to having a shotgun microphone is the fact that you will then need to position it somewhere so the orientation is close to the subject and out of frame. Having the microphone on your camera can work, but it is not ideal.

Shock Mount

By placing a microphone inside of a shock mount, you will prevent any movement of the microphone itself from being picked up. In cases where an audio operator is required to move around with the sound source especially, shock mounts are highly suggested. As a solution for decreasing the chances of capturing unwanted rumbles and shakes while recording audio, a shock mount is one of your best options. If you do not have access to a shock mount, placing the microphone in one place and leaving it alone is best practice.

Sennheiser Wireless Microphone(s)
& Receiver(s)

Depending on how portable you want your setup to be for travel, if you can take a wireless microphone set with you, I suggest doing so. Having the option to connect a lavalier microphone to them will produce the best-sounding audio. Lavalier mics are designed to pick up speech and can easily be concealed under clothes to stay out of the shot. Sometimes this is not

an option when shooting a documentary. In this case, get your shotgun or external recording device as close to the subject as possible.

Preamp

A portable sound solution to an external recording device is a preamp. You can plug your microphones directly into either the preamp or the camera (mini-jack only) and record high-quality sound directly onto the camera's CF card. The downside to this solution, however, is that when using a preamp, you will need to either be physically tethered to the microphone or have wireless microphones connected to your camera setup. This isn't always the easiest way to work when shooting on location for documentaries. I explain the benefits of preamps in on page 65.

For larger-scale productions, a field mixer and a boom pole go the extra mile in capturing quality audio. In the type of situations that allow you to utilize this large setup, the quality of the sound captured is going to be as good as you get for field shooting. Once you introduce all of this equipment though, the production is no longer as easily portable or discrete.

Gathering Footage

Take your time. Give yourself plenty of time to shoot on one subject and stay focused. Slow movements and adequate amounts of record time for each shot will translate better in telling the story. For the viewer who is not there in person, gaining insight and perspective of the environment is important in understanding the context of the story. If the shots are too quick and focus on too many things at once, the viewer is going to experience more confusion and less of the intended information. You don't want this. Take your time with the shots, it is always better to have more footage to work with in post-production than not having enough. You can always cut extra footage out a lot easier than you can add it back in. Having to go back and shoot content can be very costly.

TELLING A STORY
Take shots of the details too—a simple shot can often

EXTRA FOOTAGE
As always, insure yourself against disaster by recording

The Basics

Getting the Best Results

Lighting & Audio

Basic Tools

SHOOTING VIDEO

125

Post-production

Types of Video: Narrative

A narrative is a composition that details a sequence of fictional events. In other words, it is the opposite of a documentary. When presenting a narrative, the director is telling a fictional story. A narrative can be shot as a feature or a short. Before films had sound, the director was required to tell a compelling story by moving pictures alone. Today's modern technology has given us the advances of clear audio and beautiful visuals to help the telling of stories through video. If you can successfully translate to your audience what your storyline is without sound, you have won half the battle and have executed what a true narrative is. The audio is like the icing on the cake. Now, of course, the scripting is vital, but given the knowledge about how films used to be made, it really makes you consider the sequence of events in a more critical way. Each shot must be composed with a clear intent and be able to be communicated on all levels with your audience.

The majority of what you have learned through all of the other types of video can now be applied to shooting a narrative with a DSLR. Let's touch on a few new aspects of shooting and revisit some of the information you already understand. All techniques and gear can be applied in some fashion for shooting a narrative. In this section I'll discuss both long narrative films, or features, and short films.

Case Study 5
Narratives and Short Films

Pre-Production
The scouting, acquiring permits and storyboarding are all pretty much the same process. You will probably find these pre-production consistents to require very similar steps across the board when filming. The casting process, on the other hand, will be drastically different for a narrative than it would be for a documentary. When relaying a story of true accounts in a documentary, actors are not cast. You work with the people who are, or have been directly involved with, the topic of your film. In contrast, a narrative involves a cast of actors, therefore, the casting portion of the pre-production process must be done prior to shooting. Auditions and screen tests are often found to be the best ways to find the perfect match for each role.

POST-PRODUCTION

Production Framing & Composition

Let's go back to what you have learned about framing and composition. Each scene in a narrative film should be thoroughly thought out and planned. Unlike a documentary or a wedding, where you may not have time to set up shots and properly light or have control over colors and sets, a narrative gives you the freedom to take creative control with your shots. Some of the elements you want are dimension, a balanced usage of color and for the viewer to be able to focus solely on the main point of action. All of this comes down to designing the shots. Storyboarding can help to organize each scene so you can visualize what elements will be present in the shot and relevant to the storyline.

Set design is important in keeping the colors and balance in check. Everything from costumes to environment and the lighting will play a role in the scene. For this, think in terms of a color wheel. Take the set or environment you will be shooting in: If you can create complementary colors with the set, wardrobe, and skin tones of the actors, the shots will look more balanced. In post-production you can fine-tune with color correcting and grading.

Director's Slate

Using a slate before each take when shooting a narrative is strongly suggested. With so many scenes and takes, a slate will keep the editor informed about which take must be used for each scene. In addition to aiding the organizational process, a slate is used to sync the video files with the audio files in post-production. I detail a director's slate along with how and why one is used on page 66.

The Basics

Getting the Best Results

Lighting & Audio

Basic Tools

SHOOTING VIDEO

127

Post-production

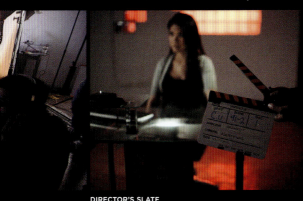

DIRECTOR'S SLATE

Lenses

Oftentimes people will ask what types of lenses to use when framing. Remember that the lens is not what will determine whether the frame can work or not, the lens will alter the perspective, but you can still achieve a variety of frames with most lenses. If you are using a zoom lens, your options increase even more than if you only have a fixed lens. You can move the camera further away or closer to the subject to achieve the frame you wish to capture. The perspective, however, will change and therefore, your shot will have a different look. If you are using a zoom lens to get a close shot from far away, you will effectively zoom in on everything in the shot, not just the subject. The perspective of that shot will change. Play around with your lenses and framing. Once you begin to do this, you will gain a better understanding of which lens you prefer for the differing types of frames.

In the case that you cannot optically zoom, move your camera in closer or further back. If you want to keep to a certain perspective, then you will need to use a lens that is best for the distance between it and your subject. There is no one perfect answer for which lens to use, experimenting is the best way toward begin to understand your lenses and which will produce the look you are envisioning.

OPTICAL ZOOM

A good rule to follow is to avoid zooming in on your subject. If you need to get a tight shot, bring the camera closer in toward the subject rather than zooming in. You will change the perspective of the shot if you optically zoom as a solution to getting a tighter shot. When you optically zoom in, you in effect zoom in on everything within the frame. Unless you have no other options, I suggest that you avoid doing this. Aside from changing the perspective, you also are more likely to make the images soft and not as sharply focused.

Basics

Getting the Best Results

Lighting & Audio

Basic Tools

SHOOTING VIDEO

129

Post-production

Lighting

Every your scene needs attention paid to the lighting. No matter the scene or availability of natural light, anything shot should be additionally and intentionally lit. When shooting a narrative, it is ideal to have both the time and the control over each scene to craft the desired lighting look you are trying to achieve.

For a scene that is shot to intentionally appear to be low light, a light source will still be used. Although an LED 900 light panel is illuminating the subject for this short, the overall look will be altered in post. The light ensures that all of the necessary picture information for the subject and scene is recorded.

Low Lighting

Try to avoid night scenes where you will need to shoot in very limited, low light. Even for films that appear to be shot in the dark, there is actually an ample amount of lighting in the raw footage. After the "low light" scenes are shot in properly lit conditions, the look of the video is altered in the post-production process. There is more control this way and it is much easier to shoot video when the controlled sets are well-lit.

CONTROLLING LIGHT

LIGHTING

By not relying on ambient light alone in the scene above and lighting it with an LED, we retained control of the environment and ensured that all of the detail

SET DESIGN & LIGHTING

When you're not designing a set from scratch and are
working within a pre-existing space, make the most of
what lighting can offer. We created a harsh, alienating
atmosphere in this scene by manipulating the lighting.

External Monitor

If you're working on-set as a camera operator
along with a director, you might require an external
monitor to share your framing and composition.
Set designs and lighting will look very different
through the lens of a camera, than what you see
with average eyes. With an external monitor, the
director can get a general idea of what will be
recorded from the camera without having to
hang over your shoulder, or peek through your
viewfinder. There are ways to send this video feed
wirelessly if the director is away from the camera.

Most average DSLR cameras will disable the
on-camera LCD display when an external monitor is
attached to the HDMI port. If you have to share the
video output, you should choose a monitor with an
HDMI pass-through so that you can view one monitor
while sharing the feed to another for the director to
view. If the external monitor has focus assist and
false color features, this will aid you in judging focus
pulls and setting proper exposure.

ROOM TONE
Room tone was recorded for this scene while all of the extras stayed in their positions.

Audio

When shooting a narrative, using an audio operator to monitor the sound quality is extremely important. A field mixer will accept multiple microphones and be able to fine-tune and accurately monitor the incoming levels. One of the first indications of an amateur film is bad audio. The audio operator should understand how to properly outfit the cast and set to capture optimal sound. Remember to record room tone and ambient sound to mix the audio with in post. Before and after shooting each scene is a good time to get these recordings. This practice ensures their capture. Additionally, all of the actors and props are in the same positions they will be in while they are performing. If you attempt to do this after the cast and set has been moved around, room tone and ambient recordings will sound different.

the Basics

Getting the
Best Results

Lighting & Audio

Basic Tools

SHOOTING
VIDEO

131

Post-production

Types of Video: Music Video

Shooting a music video is a great way to start putting into practice all that you now understand in terms of shooting videos with your DSLR. Although music videos are an interpretation of the music track itself, they don't have to be related visually. The mood of a music video can vary hugely between scenes, it is all based on the vision of the director and artists.

PLANNING, GEAR, & EXECUTION
With a music video you have several short scenes that make up a kind of narrative. Storyboard carefully and plan your shots around this.

Case Study 6
Music Video

I'm going to take you through some techniques that will help you to achieve your desired look. Knowing the basic platform to sculpt light, play with settings, and color correct in post will give you the knowledge to explore and expand your practice as you shoot more.

Pre-Production
A constant and consistent aspect of filming a music video is some form of pre-production. This process is crucial in the success of shooting your video. Remember the consistent practices within pre-production? Storyboard, cast, scout, and checklist.

Storyboard
Prior to your shoot, be sure to mock-up a treatment or storyboard of some sort to serve as a reference and game plan for the actual shoot. Your storyboard (also referred to as a treatment) can be looked at like your set of directions on how the shoot will unfold. When you map out each frame and scene of the music video, you are also creating a checklist of the equipment you are going to need on the set. In addition to basic storyboarding, some directors require a very detailed treatment of the music video. A treatment and a storyboard can be the same presentation—a treatment typically includes different details. Including examples of concept such as color swatches, typefaces, and emotional references, a treatment generally will give the director a clear idea of what the final music video will look like in frames, sequence, color, composition, and overall emotion.

Scout

Scouting is another part of the process that you cannot ignore. Take into consideration not only the location itself, but where the sun is at different times of the day. Noise levels, accessibility, permission, space: the determining factors are countless, but all need to be examined before the crew and talent are called to the location to shoot.

Checklist

I always keep notes as I'm storyboarding and scouting to remind me of what needs to be included in my checklist. The checklist will serve to ensure that nothing is forgotten on the day of the shoot. I go further into detail on suggestions for what your checklist should include in the "checklist" section of pre-production.

COLOR

For an edgy, visually dynamic look, experiment with shooting your subject in a high-contrast location and then switch to monochrome.

ACCESSIBILITY

If you have extras, or even just several people arriving for the shoot, make sure your location is accessible and easy to find.

The Basics

Getting the Best Results

Lighting & Audio

Basic Tools

SHOOTING VIDEO

133

Post-production

Production Lenses

Different lenses will give your video different looks. For example, a fisheye lens can introduce distortion and give your video a stylized look. A wide-angle lens can exaggerate features when used for medium-close and close shots. A macro-lens will give the viewer a very intimate perspective of the subject's features. Choose your lenses according to what feel you are going for. Portrait lenses like a 50mm and 85mm are more flattering when capturing an artist's face than a 200mm lens zoomed in. Play with the lenses you have available and research what other shooters are using for videos that have the same look you are trying to achieve.

Styles

Choosing your sets carefully is an aspect of scouting that I find often gets overlooked. Depending on the budget and location, remember to think outside of the set variables for each setup. You can introduce props or remove unwanted items to manipulate your frame to better suit your shot. Experiment with this, play with light and props and the repositioning of your subject(s). Remember that you can cheat shots that don't quite work from every angle. Altering your environment and setup to capture the shots you want can and should be done to make a better-looking video.

Color

I suggest getting a color wheel to refer to or downloading an app that provides a color wheel that you can play with. For example, if you know your actor is going to have darker skin tones, consider complementary colors to enhance the browns or tans of the skin. A color wheel will visually show you that green and blue tones compliment these tones best. Depending on the look you are trying to achieve, keeping your shots balanced in color and composition will add to the aesthetics of the finished video.

Lights

Lighting for music videos is extremely important. Since you will most likely be laying the audio track over the video, the visuals are the vast majority of what you will need to focus on. Depending on what and where you are shooting, the lighting situation you will encounter is going to vary. That being said, lighting can become tricky, but when the basic principles are put into practice, you can begin to create almost anything out of the set you're working with.

Small pools of light will help to add contrast. These can be created with spotlights in any position. Darkening the set, bringing your ISO up and opening your aperture will give you a shallow depth of field and create optimal settings on your camera for a now low-lighting shoot. Get creative—tiny LED lights, Christmas lights, hang string lights, mount what you have available on light stands or whatever is already on the set. Lighting a set can be fun and as long as

The Basics

Getting the
Best Results

Lighting & Audio

Basic Tools

SHOOTING
VIDEO

135

Post-production

LOCATION

Above all, be sure to pick a creative and
dynamic location for your music video.

you understand the basics, you can then begin to play outside of the box. Colored light will create a look and style to the video. Gels can transform the studio lights you normally use.

Don't forget the rim light, this is a very important element when you are shooting video of people. The rim light introduces dimension and depth that really makes a difference in the final video.

Catchlights are often very prominent in music videos. Sunglasses really highlight catchlights, as the reflection exaggerates this light source. A ring light is a popular tool for music videos. Ring lights not only light the subject evenly, they also add a stylized look to the video.

Techniques

In the case that the background in the shot you have framed is not something you particularly want to see, there are techniques to defocusing or darkening the backdrop so it is not clearly seen in the video. By keeping a low-key or dimly lit background, but keeping the subjects in the foreground lit up and in focus, you can direct the viewer's attention to the subject and the action, along with changing the look of the undesirable background. Since there will only be light on the subject in this situation, you want to really direct

the throw of the light that you're using strategically. Generally, light coming from below the eyeline or center axis of the eyes tends not to be as flattering as light being directed from above the eyeline. Whenever you have a very dark background and a single light source, I always advise introducing a rim light. This will separate the subject from the background and the image will not appear flat. Especially after color correcting and crushing the blacks even further, the separation light will help to make the subject stand out as well as bring dimension to the video. Losing the intended focal point to a very distracting background should be avoided at all costs.

Gear

Sliders, stabilizers, and jibs are popular tools on music video shoots. All of these items allow the shooter to achieve the dynamic movements that bring the value of production to a professional level very quickly. You can acquire this type of gear easily nowadays and once shooters see the results, the impact cannot be denied. I go further into what these tools are and give tips on how to use them on pages 158–163. When shooting a music video on your DSLR, these three pieces of gear are popular go-to items that are affordable and make a world of a difference.

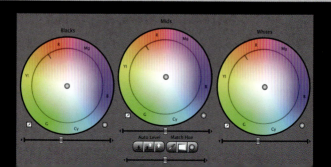

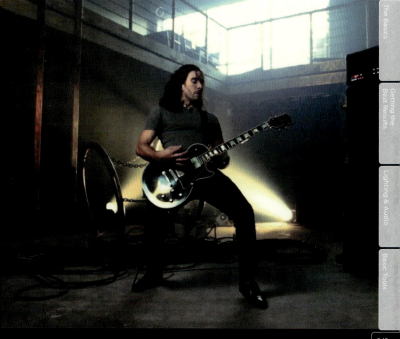

BOOSTING THE CONTRAST

We boosted the contrast of the footage, increasing the intensity of the blacks in the image and decreasing the strength of the whites.

COOL COLORS

The look we wanted to achieve here was quite muted and industrial, so we kept the tones quite cool and blue, which contrasted nicely with the dramatic background spotlights and the light streaming in from above.

Creating Standard Sets

Creating an Infinite White Background

An infinite white background is a popular and clean way to present your videos. Especially when shooting product videos, tutorials and corporate videos, infinite white has been a leading style for a few reasons. There are no distractions, so the viewer's attention stays on the subject.

When shooting on an all-white backdrop, you can move the subject around in post or key-in images, text or video very easily. An all-white set can be easily manipulated in post-production. When creating an OliviaTech video for the blog, I often use this setup in our small studio space. I'll detail the simple step-by-step instructions on how to achieve this look and show you just how inexpensive it can be.

Three Key Points to Remember for Infinite White:

1 Light and overexpose the background—light light light! You want your backdrop to be spotless and even. Light is the key element in achieving this. Softboxes or diffused light fixtures will create a pleasing key light for your subject.

2 Pull your subject away from the background. The space in-between the subject and your background is important in maintaining the overexposed white.

3 Light your subject separately and adjust as needed. The subject is the main focus point of the video so you must properly light it separately in order to achieve the proper exposure.

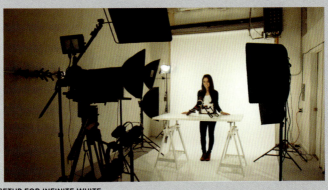

SETUP FOR INFINITE WHITE

The Basics

Getting the Best Results

Lighting & Audio

Basic Tools

SHOOTING VIDEO

139

Post-production

UNDERSTANDING INFINITE WHITE

That is Your Foundation, Now Let's Understand the Process:

1 Your background starts with a white seamless paper backdrop on either a backdrop stand or hanging from a wall-mounted background support. Using paper instead of cloth leaves no wrinkles for shadows to appear. This also applies to creating a better green screen for keying out subjects.

In the setup that I so commonly use for OliviaTech videos, six CFL (compact fluorescent light) softboxes are used. For small studio spaces, four light sources will be a sufficient amount of light, six CFL softboxes are not always necessary. Each CFL softbox contains five CFL bulbs on a head. The light output can be adjusted independently by powering the individual bulbs within each softbox. Each head has a dedicated softbox and two layers of diffusion for flat even lighting. CFL bulbs don't draw much power and don't generate a lot of heat. In small studios or homes, these are a nice alternative to spotlights which can get extremely hot.

2 In your camera's picture style, you want to bring your contrast and saturation all the way down. This will give you flat tones to work with. In post, if additional adjustments need to be made, you can do this more easily if the image is flat.

3 Bring two to four of the lights to the back to light your white backdrop. You want to overexpose for the white so it is completely blown out. By overexposing whatever camera settings you intend on using for the video, when directed at this backdrop, they should be blown out.

4 Pull the subject away from the background, far enough so you can maintain the overexposure.

5 Use two of the lights in front of your subject as key lights. This part is important: here you must properly expose for the subject. Now, dial in the camera settings for proper exposure of your subject, the back should remain overexposed since there is much more light being introduced to the backdrop than on your subject.

Play with the distance between the subject and the key lights. I've come to learn that this is really important in the end result. Remember, you can make some minor adjustments in post as well.

6 After shooting, some minor color adjustments are typically created in the post-production process. We add contrast and boost color with saturation.

Creating an All-black Background

Shooting a video against an all-black backdrop can look extremely clean and add a moody dynamic or a certain style quality to the presentation. One of the most common obstacles that people run into when shooting on all black is the subject getting lost within the backdrop. When lighting on all black, it is key to separate your subject from the background to avoid running into this problem.

1 Since the backdrop is going to be completely black, this isn't as fussy to deal with as white. Seamless black paper or muslin is your best bet, but not everyone's budget can facilitate this. In the event that you need to achieve an all-black set with a bare-bones budget, a black bed sheet will do.

2 First, kill all of the house lights. Ambient light will ruin this look by lighting the black.

3 Pull your subject as far away from the backdrop as possible.

You will need three types of light sources for this: a key, fill, and a rim or separation light. The separation light is particularly important for subjects wearing dark clothing or who have dark hair.

4 The key light will act as the main light source on the subject. A diffused key light usually renders the best results, as it is not too harsh and doesn't cast very hard shadows on the subject. This is normally true for both people and products.

5 The fill light acts as a filler in the areas where the key light is not able to hit. If you don't have a fill light, a reflector may do the trick. Play with the light and see what gives you the best results. A light stand and a C clamp might be able to hold the reflector in place.

You do not want any light leakage onto your backdrop. This is very important. If light from your key or fill is spilling out onto your backdrop, you will ruin the infinite black background you are striving for. Using a flag or simple foam board will counter this by blocking the light spills. Be very diligent in double checking this aspect of your shot.

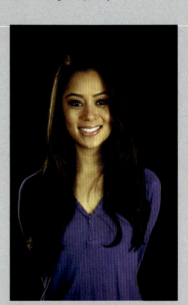

SETUP FOR AN ALL-BLACK BACKGROUND
This very clean studio setup focuses your audience's attention on the subject and not the surroundings. Placing a light behind the subject gives their shoulder and hair a rim light. This helps separate them from the background.

6 Last, position a rim or separation light behind your subject to create an outline of light around them. This light is what will separate the subject from the black background. If the rim light is left out, the subject will have no depth and get lost in the black. The positioning of the separation light can be in various areas. This depends on your setup and what you have to work with. I suggest positioning the rim above and behind your subject for best results. This way, the light will hit the subject evenly and can reach an entire person's body if positioned correctly. You can also set the rim light up off to the side and behind the subject. In this case, be sure that the light is hitting the back side opposite the key light. This will help to separate the areas that are not as well-lit.

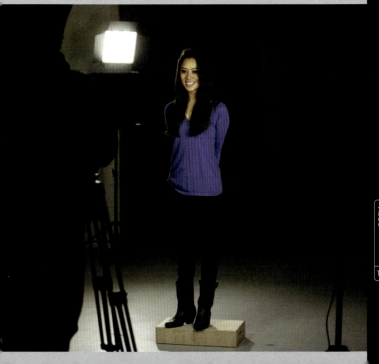

The Basics

Getting the Best Results

Lighting & Audio

Basic Tools

SHOOTING VIDEO

141

Post production

Chroma Key

Chroma key is a technique where you are essentially layering two images together. You then make one color in the top layer transparent to reveal a second image behind it. We see this most often on the news. The weather anchor stands in front of a green screen and moving Doplar images navigate us through an onslaught of temperature and precipitation information.

The way this works is, well—it's magic. Or more technically speaking, a color range in the top layer is made transparent to reveal an image behind it, while everything else in the top layer is keyed out to remain within the back image. In the post-production process, a few key steps are taken to complete this look and reduce any visible color separation of the layers.

Size & Lighting

When purchasing a backdrop for your chroma key setup there are a few factors to consider ahead of time. Space, lighting, and material. First off, what size is the space that you will be shooting in? By understanding how much green you will need to properly light, you can be sure that you have an adequate light setup. Chroma key requires a lot of light. You must be sure that the entire backdrop is completely lit up. You can begin to outline

ORIGINAL IMAGE

GREEN BACKDROP

BACKGROUND IMAGE

STEP 1
Shoot your video with your subject in front of the pulled-taut backdrop, and select your desired background image.

STEP 2
Once inside your editing package then use chroma keying to remove the green backdrop.

STEP 3
This can then be replaced with a background still or video of your choice.

your equipment according to these requirements. The amount of lights that you decide to use to light your chroma key backdrop are not as important of a factor as simply understanding their luminosity or light throw. If you know the intensity of each light, you can then make an estimation of how many you will need to ensure your backdrop is entirely lit.

Material

The material you choose as your backdrop will determine what you are able to do with it. For example, will you need to travel with your chroma key backdrop? Seamless paper comes in heavy, large rolls. For stationary studio use, these are extremely convenient. On the other hand, if you are planning to travel with your setup, a seamless paper roll is not exactly an ideal solution. Muslin or cloth (fabric) backdrops can be folded and reused. The only downside to using fabric material is the wrinkle factor. Keeping a steamer on-hand to take the wrinkles out is useful, since these wrinkles can also create shadows that are more difficult to key out in post-production. Pulling the material taut is another measure you can take to ensure wrinkles do not create shadows in the backdrop. Clamping the fabric and pulling on all ends will help remove them.

The Basics

Getting the Best Results

Lighting & Audio

Basic Tools

SHOOTING VIDEO

143

Post production

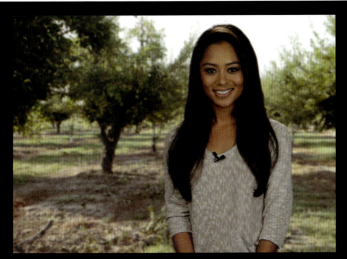

FINAL IMAGE

ReflecMedia's LiteRing

For a unique chroma key solution that doesn't require additional lighting for the backdrop, ReflecMedia makes a product that addresses both transportation and lighting concerns. ReflecMedia's LiteRing paired with their Chromatte backdrop is a portable green screen (or blue screen) solution. A single light source from a special LED LiteRing provides all the light required to illuminate the Chromatte background. You only need to consider lighting your subject. You will not require extra lighting for the special ReflecMedia background as you normally would with a traditional chroma key setup.

The key to ReflecMedia's design is the Chromatte fabric combined with their LED LiteRing. The Chromatte backdrop consists of tiny glass beads that reflect the green or blue light coming from the LED lights that are housed within the LiteRing. An adapter that is fitted to your lens threads on and the LiteRing screws onto the adapter with a single screw. The LiteRing goes directly around your lens. It is a simple method, yet a difficult one to explain unless you see it in action.

Since this is not a conventional chroma key setup, I'll list some of the pros and cons I've found in using ReflecMedia's LiteRing and Chromatte backdrop to help you better understand what to expect from the unit.

Consistency

Lighting is extremely important when shooting on a green screen. You must first properly and sufficiently light the backdrop so that you can get a consistent color. Uneven shadows on the chroma background can be difficult to resolve in post-production. Depending on what scene you're depicting, you must also

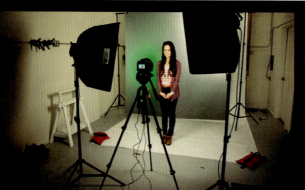

LIGHT YOUR SUBJECT
Evenly light your subject with a key and fill light. A combination of one large and one small softbox works well for this setup.

properly light your subject to match the scene you will key them into. If you want to create a sunset on a windy day, you need to light the subject in a fashion that will mimic the temperatures of being outside against a setting sun. To introduce the wind, you will also need an artificial wind source, like a fan, to blow the hair and clothing accordingly. This means taking the strength and direction of the wind from the background image and matching the fan's mechanics and orientation. A chroma key shoot can look artificial very easily if it is not shot properly. Attention to the small details is important to keep the consistency of the environment.

You should match the studio camera's movements to the clip you are keying in. If the keyed-in scene is static, you will want a static shot in the studio. The subject can move around within a static shot, but if you begin to track the subject and move the camera, the final outcome will look confusing, as the keyed-in scene is static. You can use the information of the scene you are keying your subject into as a reference guide to effectively piece together what should be moving and what should remain static.

The Pros & Cons

Pros: Portability and cost. This entire unit is extremely portable and even has a pop-up backdrop option. The Chromatte coupled with the LiteRing does not require separate lighting for the backdrop—so again, less equipment.

Cons: This design is not made for outdoor shooting. The LED light is not powerful enough to reflect onto the ReflecMedia backdrop in bright ambient settings. Thus, this investment may not solve all of your chroma projects.

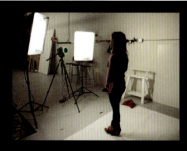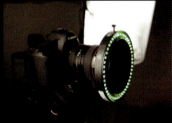

LIGHTRING

Alternatively to using a green cloth you can use a LightRing and ReflecMedia background to shoot your chroma keyed video.

The Basics

Getting the Best Results

Lighting & Audio

Basic Tools

SHOOTING VIDEO

145

Post-production

Shooting a Product Video

Product videos must be two things: well-lit and have an extremely clean view of the product. In order to achieve both of these, there are a few techniques that must be considered. Let's run through a basic step-by-step process to help you understand a few simple practices for properly shooting products in a studio space. For this example I'm going to use the infinite white setup as the backdrop. You can apply the basic lighting understandings you've learned in this book to any type of backdrop you choose to use. Now that you know how to set up and light for infinite white, we'll cover how to shoot products. Remember though, a seamless and clean backdrop is suggested as common practice for a product video when you want to see the product only.

It's very important to have a rock-solid tripod to mount your camera on. Coupled with the tripod, a video fluid head is best suited for this situation. Since the video is zoned in on one main focus point, and often shot with a macro lens, having an extremely steady tripod and smooth video fluid head are vital in creating a successful product video. It is best to position the camera for an equal level or low shot. This way the lens is pointed at the product and nothing else. In other words, if the product is on a stage, you will want the lens of the camera to be pointed directly at the product. Of course, this depends on the style of shooting and what perspective you want to create. Normally, the potential customer wants to see the product up close and from all angles. We'll touch on

LONG LENS

Product shots need to focus on the detail of a product. A longer lens will provide a narrow field of view and shallow depth of field, drawing the audience's attention to the aspects of the product you want to show.

this in a moment. Pointing the camera at the same level as the product also ensures that only the backdrop is seen.

Just as important as it is to be sure to have a sturdy tripod and video fluid head, you want to also be certain that your product is sitting on a steady surface. Your stage can be anything that works best to suit the needs of your shots. A tripod with a video fluid head or a lazy Susan turntable will allow you to rotate the product a full 360°. In this case, since we're shooting on all white, we'll want to be cautious of what is in the shot with the product. Another option is to use an all-white surface that you can blend into the background in post-production. This will give the look of a floating product. You can certainly stage your product on any color.

Infinite White

Refer back to the infinite white section of this chapter for instructions on how to properly light this setup for your product shoot.

This part is important so I will restate: You want to overexpose for the white so it is completely blown out. By overexposing, this means that whatever camera settings you intend on using for the video, when directed at this backdrop, they should be blown out. Next, you must properly expose for the subject. Now, dial in the camera settings for proper exposure of your subject. The back should remain overexposed, since there is much more light being introduced to the backdrop than on your subject.

The Basics

Getting the Best Results

Lighting & Audio

Basic Tools

SHOOTING VIDEO

147

Post-production

Play with the distance between the subject and the key lights. I've come to learn that this is really important in the end result. Remember, you can make some minor adjustments in post as well. In your camera's picture style, you want to bring your contrast and saturation all the way down. This will give you flat tones to work with. In post, if additional adjustments need to be made, you can do this more easily if the image is flat. Now that the background is lit, and the product and camera are placed, you must light the foreground. In this case, we're going to focus on the surface on which the product is placed—the white surface.

For the key light, one or two lights with softboxes will provide a sufficient amount of luminosity. This may depend on how large your product is. Be sure that no light is spilling onto the background. You can use a flag to prevent this.

Now to light the back of the product— this creates a separation between the product and the background. Using a rim light, you will light the back of the product, creating highlights and separation. This also adds depth and dimension to the product so it isn't left flat. Using glass as your stage is another technique for product videos. Glass will give a different look to the end result: the product can appear to be floating and even have a reflection. For this setup you must also have a white surface beneath the glass. Blowing out the white surface under glass is done by the same method as with an all-white surface. The goal is to have all of the whites seamless and saturated.

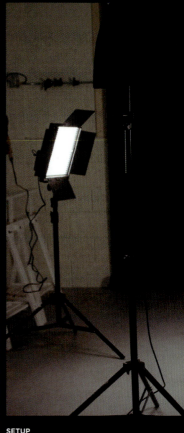

SETUP

Soft lighting with a black backdrop will create a clean uncluttered environment to capture your product shots.

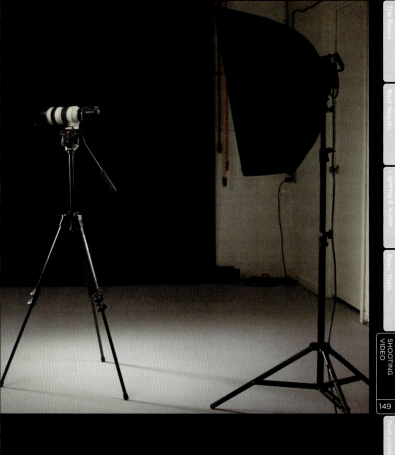

The Basics

Getting the
Best Results

Lighting & Audio

Basic Tools

SHOOTING
VIDEO

149

Post-production

Focusing Tips While Shooting

This section is a quick reference guide for a few focusing tips to help you when shooting videos on your DSLR. Based on focusing techniques alone, you can really get creative and add impact to your scenes by knowing and manipulating focusing tricks.

Part of the beauty of video on a DSLR is being able to highlight the creamy bokeh that DSLRs are capable of capturing. While high-quality glass can completely transform a picture, almost any lens is able to perform these basic focusing techniques that can add personal style and emotion to your videos.

Digital Zoom

Take advantage of your digital zoom feature when achieving critical focus. If you simply zoom in to the focal point in order to focus, the lens will not maintain focus. By utilizing the 5× and 10× zoom on your DSLR, you can hone in on the focal point accurately to get a sharp focus.

With a magnified view and a magnified area position you can see your critical focus better to be sure that it is sharp. This technique is only available prior to shooting video. Once you start recording, you cannot perform this type of digital zoom, so be sure to check your focus each time you move the camera.

DIGITAL ZOOM FEATURE **CHOOSING THE DETAIL AREA**

DEPTH OF FIELD: DIRECTING ATTENTION

RACK FOCUS: FOCAL POINT AT FRONT

FOLLOW FOCUS MARKING

RACK FOCUS: FOCAL POINT AT BACK

The Basics

Getting the Best Results

Lighting & Audio

Basic Tools

SHOOTING VIDEO

151

Post-production

Depth Of Field

You can use the depth of field to direct the viewer's attention and tell a story. When utilizing a shallow depth of field to select your focal point, you can direct your viewer to where you want them to hold their attention. One static shot can focus on multiple distances to tell a story. This technique is called rack focusing.

Rack Focusing

Rack focusing is when you shift the focus point from the subject in the background to the subject in the foreground or vice versa. You can get creative and run your focal point along a distance as far as your lens' focal distance goes. This technique is often used in dramatic scenes or just to give a different perspective on something that would otherwise appear ordinary. Directing the viewer's attention by focusing in on only what you intend them to see is another way to tell a story.

Follow Focus Marking

When using a follow focus, you can mark areas on the turn style to indicate stopping positions for multiple focus points. A grease pencil or dry erase marker is typically used for this. By marking the track, a focus puller can follow the points of where to start and stop to achieve focus, and once you've determined this, you should mark both your positions on the follow focus for a perfect result every time. When there are specific end marks that the director wants to focus in on before the scene is shot, each landing position on the follow focus is marked. When filming begins, the focus puller dials the follow focus from one point to the next to ensure accurate focusing.

Shooting in Low-light Conditions

Due to the sensor size, the native low-light sensitivity on a DSLR far surpasses the image results you will get with a traditional video camera. Beyond that, DSLRs allow far more control of the settings that will enable beautifully shot scenes with very small amounts of available light. While shooting video in low lighting conditions, there are a few key factors that you must take into consideration. Oftentimes, videos shot in low light will either be too dark and underexposed, or too much noise and grain will be present. Let's take a look at some of the settings that you must be aware of to achieve a sharp, clean, and well-lit video.

Aperture

You do not want your aperture to go any smaller than ƒ/5.6. The wider open your lens can go, the better, as more light will be allowed to enter in through the iris. Once you go smaller than ƒ/5.6, not enough light is able to hit the sensor and the image won't be properly lit.

ISO

As we discussed earlier in the book, a very high ISO will introduce noise and grain. Even when shooting in extreme low light, it is not advised to go higher than 1600. If you do, the likelihood of getting unwanted grain increases. Keep your ISO in the golden numbers of 1250 or 1600.

NOISE & GRAIN

For this scene we kept our ISO at 1400, avoiding any grain.

The Basics

Getting the Best Results

Lighting & Audio

Basic Tools

SHOOTING VIDEO

153

Post-production

BOOSTED CONTRAST

A successful example of a low-light scene with boosted contrast.

Shutter Speed

If you want a cinematic look, keep your shutter speed at 1/50 second. When shooting in low light, stay between 1/40 second and 1/50th second for the best results. Fluorescent lights that aren't rated for film have a flicker. Once you go outside of 1/40 second or 1/50 second, this flicker will be detected by your DSLR. Go slower than about 1/40 second and the video may look blurred, go too much over 1/50 second and you can get a very staccato video.

Picture Style

Set your picture style to no contrast. Once you take the contrast all the way down, the picture will not be as dark.

Light

No matter what, you must have light. Choosing a location that has multiple sources of small amounts of light will do. Street lights, the head and tail-lights from passing cars, any available light possible needs to be present in order to achieve favorable low-light results. Of course, the more light there is to work with, the better your odds are of getting usable content.

If proper light treatment is possible, you should always light your scenes. Even if you intend on capturing a dark mood with a high-contrast look, it's all about lighting and touching up in post-production. All dark movie scenes are shot with adequate light. Only when you cannot properly light should you take other measures to use the available light in the given environment. With attention to the

variables listed, you'll be best suited for capturing quality video, even in extreme low lighting. You want a fast lens since you want to keep your aperture as wide open as possible. Also remember to keep the ISO high.

MOOD LIGHTING

Different areas of this bar had varying kinds of lighting, which both posed a challenge to light correctly and allowed us free reign to capture a variety of effects. The light in the shots to the right had a lovely warm glow to it, while the fluorescent sign in the shot to the left gave an entirely different feel.

The Basics

Getting the Best Results

Lighting & Audio

Basic Tools

SHOOTING VIDEO

155

Post-production

Utilizing Depth of Field for Effect

Always remember this phrase when dealing with aperture, "more is less." This helped me understand the sometimes confusing concept of the camera's aperture and how the *f*-number correlated to being either wide open or closed down.

Wide Open or Large Aperture (Example: *f*/1.8)

When shooting wide open, your depth of field is very shallow. This means that the defocused areas are much greater than what is in focus. This creates the look that DSLRs are known for. Defocused points of light known as bokeh also become beautiful when you shoot wide open. If you wish to have a wide aperture, but there is too much light in your environment, utilizing ND filters will allow you to maintain a shutter speed of 1/50 and stay wide open. Having the ability to shoot with a shallow depth of field expands the range of possibilities you have for creating dynamic shots using this one single technique alone.

LARGE APERTURE

The shallow depth of field on this shot below will focus the audience's eyes on a specific area of the image. This is known as selective focus.

Closed Down or Small Aperture (Example: *ƒ*/11)

If you want everything to be in focus while you're shooting, closing your aperture down will allow you to achieve this. Your depth of field is much greater and therefore very little to no area of your shot will be defocused. You can ensure this type of focus by using your hyperfocal distance. Generally, everything from about half of this distance to infinity will be in focus. Depending on what you are shooting and what look you're going for, you may need to have your entire frame in focus.

SMALL APERTURE

In this shot everything is in focus—this comprehensive depth of field is great for use in establishing shots, or shots intended to show detail.

The Basics

Getting the Best Results

Lighting & Audio

Basic Tools

SHOOTING VIDEO

157

Post-production

Shooting Tips for Gear

Shooting with a Monopod

Monopods are not as stationary as tripods, because of course they only have one point of contact with the ground. Even monopods with small additional feet are not stable enough to stand independently if the equipment isn't completely evenly balanced. In order to further steady your shots while using a monopod, a few simple tricks can go a long way to increasing your stability.

1 Positioning

If you are using a video fluid head with a pan arm, by tucking the pan arm in under your armpit, you can free both of your hands. The more points of contact with the monopod you make, the steadier the shots will be.

2 Focus

Rather than focusing in on a subject at the end of a moving shot, focus in first, pull the camera back and track back to the subject. This way you can avoid having to worry about focusing in on the subject during and after your camera movement.

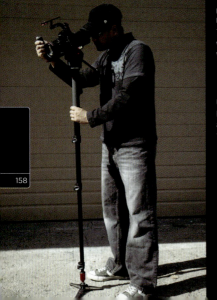

MONOPOD: POSITION

Tuck the pan arm under your armpit to free both your hands.

MONOPOD: FOCUS

Pull the camera back and track back toward the subject.

EXPERIMENT WITH MOVEMENT

Don't just set your slider up horizontally—they also work great vertically, as well as placed at 45° angles.

Slider Techniques

Your gorgeous sliding shots will result in an epic failure if the track is not properly balanced on a steady surface. In order to optimize the abilities of your slider, you must also understand how to properly use your camera's functions while creating sliding movements. Sliders come in an assortment of styles. When shopping for a quality slider that will give you the most versatility, look for one with feet to stand on and 1/4-20" and/or 3/8-18" threaded holes in the track. These threadings will serve as mounting points for you to fix the slider onto a tripod, light stand, or a pair of either. Without stationary mounting points, you will not get steady shots.

The Basics

Getting the Best Results

Lighting & Audio

Basic Tools

SHOOTING VIDEO

159

Post-production

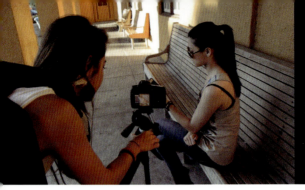

Reveal

When shooting videos using your slider, there are certain techniques that aid you to tell the story. The reveal technique is used often for impact and to give your viewer insight into what is taking place. Sounds can help the reveal also, but the simple trick of sliding into a scene is great for beginners gaining an understanding of how to build the story. Begin at a point where the viewer doesn't see the subject, and then slide into frames where the subject and supporting actors or scene are. Always start sliding *before* you begin the scene, or cut into it while the camera is already sliding into post.

Push/Pull

You don't always have to slide right to left. Try pushing your camera toward the subject and pulling away from them. Use the depth of field techniques you have learned to make these shots even more dynamic. Passing objects as you slide your camera along the track can also create a series of focal points to direct your viewer's attention.

Vertical Movements

If you mount your slider onto a tripod and flip it vertically using a ball head, you can capture vertical shots. Reveal something from the ground up or top to bottom. This is one of my favorite ways of using the slider. It can be a tricky technique to pull off successfully, but this type of shot really adds impact to your video.

Use your imagination, get creative and innovative, but whatever you do, just start playing around with your camera and slider. Once you begin to mess around with the settings and techniques you'll gain a much better understanding of how it all works and what your shooting style is.

Tracking

For tracking shots, you follow a subject along the single axis of the slider track. Sliders built for DSLRs tend to be on the shorter side compared to dolly tracks that are laid out on the ground for tracking. To get the full effect of a sliding shot, all you need is a two- to three-foot-long slider. It is not about how long it is as much as how you slide your camera. If you provide foreground objects, you will see more of the slider's movement. Capturing objects that are closer rather than much further away will also result in seeing more of the sliding effect. Keep this in mind as you set up your shots.

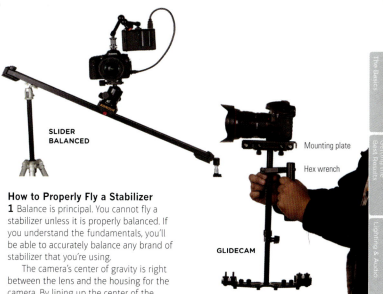

SLIDER BALANCED

GLIDECAM

Mounting plate

Hex wrench

The Basics

Getting the Best Results

Lighting & Audio

Basic Tools

SHOOTING VIDEO

161

Post-production

How to Properly Fly a Stabilizer

1 Balance is principal. You cannot fly a stabilizer unless it is properly balanced. If you understand the fundamentals, you'll be able to accurately balance any brand of stabilizer that you're using.

The camera's center of gravity is right between the lens and the housing for the camera. By lining up the center of the mounting plate with the center of the camera, you will ensure most control when dialing in your X and Y axis points on the stage. Attach the mounting plate to the camera with the screw provided. Typically this is a 1/4-20" male screw that threads into your camera body. Attach the camera to the stabilizer and lock into place. This will probably be done by way of a quick-release plate.

2 Lining up your horizontal balance can most often be done by using a simple hex wrench on Glidecam stabilizers. The hex wrench allows you to dial in the camera's left and right balance. Check your equipment to see how and if you have the option to do this.

3 By adjusting the dials on the stage either clockwise or counterclockwise, you would adjust both the front to back and side to side balance of the camera. This is done ever so slightly, as a small micro adjustment can tip the camera. The weight can shift very quickly as a stabilizer is so sensitive to weight.

If your stabilizer does not allow you to make micro adjustments, there may be a cheese plate with multiple mounting points. The level of adjustment allowance typically correlates with the retail price of the stabilizer.

When holding the setup by the stabilizer's handle, you can judge by the balance whether or not the unit is sitting even while it is upright. Some stabilizers come with a cradle for mounting so you don't have to hold the unit while making adjustments.

BALANCING ACT
Once you have correctly balanced your rig, you should be able to walk and run with your camera whilst maintaining a smooth shot.

4 The counterweights at the base platform and their positioning will determine how long it takes for the unit to move from a start point to an end point. By loosening the telescoping clamp on your stabilizer, you can adjust the drop of the base platform, therefore changing the vertical balance of the stabilizer. (This applies only to stabilizers that have a telescoping feature.)

Rather than adding counterweights, by dropping and retracting the base platform, you can significantly alter your counterweight without adding pounds to the entire setup. This is important to

understand, so you don't end up with a monstrosity of a setup that you can't hold up for more than 15 minutes. When the drop time of your setup needs to be increased and you cannot telescope the base platform any lower to the ground, you must add counterweights. Always be sure to add your weights in even increments to retain symmetry.

Now that you're properly balanced, the fun part—you're ready to fly!

5 Controlling a stabilizer is all about as little friction as possible. If you are right-handed, you will hold the handle with your

The Basics

Getting the
Best Results

Lighting & Audio

Basic Tools

SHOOTING
VIDEO

Post-production

right hand and pinch, just under the gimbal, to control the direction of the shot. You want to guide with your left forefinger and thumb. Be careful not to grip the bar, as this will cause the setup to pendulum. You want your camera to float through space, not rock back and forth. The trick to this is creating as few fixed points of contact with your hands as possible. When you add friction, you take away from what the stabilizer should do: float your camera.

6 Lastly, the way in which you walk also adds to how steady your shots are going to turn out. If you do not allow your knees

to absorb the brunt shock of walking, you'll have to be more crafty with your hands. Make it as easy on yourself as possible and avoid locking your knees. Rather than walking as you normally would, glide—the difference is noticeable! As with anything else, this is all about practice, practice, practice. You can also pan and tilt with these units.

General Shooting Advice

Panning & Tilting
Controlling your shots is crucial in perfecting visually pleasing videos. Panning and tilting should not only be silky smooth with no bumps or jitter, but they also need to be done slowly enough in order to capture the environment. If you pan or tilt too fast with a DSLR, any lines in your shot can appear to skip.

Jello Effect
The rolling shutter can make some straight objects appear to turn wavy. This is known as the jello effect. In video mode, the sensor scans pieces of the image across vertically—not all at the same time. If the camera is panned too quickly, vertical lines in the image begin to tilt, since the scanning of the image is happening at the same time of the pan. In order to avoid this sort of distortion, panning slowly is your best solution. Additionally, many vertical lines will create a greater number of challenges with a rolling shutter. Avoiding a lot of camera movement when shooting vertical lines or avoiding the access of vertical lines altogether can alleviate this effect.

10 Seconds, Slow Pan/Tilt, 10 Seconds
A good practice to follow to avoid this unwanted effect is the ten-second rule. Start recording your video and hold the beginning position for ten seconds. Pan or tilt very slowly and at the end point hold the position for another ten seconds before you end the recording.

164

PERSPECTIVE
Videoing children at play is a classic example of how a different perspective can impact your movie. To get a child's-eye view of the world, shoot down at the level of the children. Alternatively, videoing them from above against the surrounding landscape will give a sense of their vulnerability and smallness.

JELLO EFFECT/ROLLING SHUTTER
When panning across these blinds the jello effect is obvious in the distortion of the vertical lines.

Changing Up Perspective

A shift in perspective can completely metamorphize your shot. Changing the camera's perspective is a powerful tool that you always have available. This could potentially give the viewer a novel look at something as ordinary as a garbage can. Don't be afraid to step outside of the box when shooting video: taking on new perspectives is an art, embrace it and make this a common practice. You'll begin to see your shot compositions with entirely new eyes. I oftentimes just go out and take still photos to practice switching up my perspective. It helps when I'm shooting video because I have visual reference points.

Aliasing

Aliasing is a common problem with DSLR cameras. Since they were designed mainly to shoot photography, in order to produce video, the camera must shrink resolution from 5616×3744 to 1920×1080. In this process, the camera skips lines and leaves out some information. The high spatial frequency can result in terrible moire interference patterns that create what looks like moving lines most commonly across certain patterns like bricks, striped shirts, and tiles.

VAF-5D2

You can purchase a filter like the VAF-5D2 for Canon's 5D Mark II that is installed into the camera and can be easily removed. The VAF-5D2 anti-aliasing filter is designed specifically for the pixel pitch of the Canon 5D Mark II imager. Made with multiple layers of birefringent material, including lithium niobate and crystalline quartz, it truly is a unique optical solution. Installation requires no modifications to your Canon camera.

Original Canon camera files and 1920×1080 H.264 versions of various test videos are available for download and evaluation at: www.przyborski.com/mosaic_downloads.html

Note from Mosaic Engineering

Whenever a space is created between the back of the lens and the CMOS image, you change the apparent flange focal distance optically between the lens and the imager. With the implementation of the VAF-5D2 anti-aliasing filter, the lens will in effect think it is 1–2mm closer to the subject.

This means that with it installed, the indicated focus on your lens isn't going to be the same as your actual focus. The choice is between higher image quality versus being able to know focal distance by way of the numbers on your lens. Your zoom lens becomes a variable focal lens as opposed to an actual zoom. It will not track focus with this device, you must zoom in or out until your scene is framed, then focus. Designed for lenses between 35mm and 500mm, the VAF-5D2 filter produces less than 1/4 stop of light loss, renders over a 75% reduction in aliasing and morie pattern interference, provides full 700 lines of resolution and at a wide aperture, 24mm lenses will lose some sharpness at the left/right edges.

FILE ORGANIZATION

The shooting is the hard part, which makes it almost ironic the mess people can get into with file storage on their projects. It's easy to cut corners when you're in the middle of something and save a file just anywhere, but an up to date, organized project folder will always pay dividends in the end.

Shoot More

Having more footage to choose from is better than having too little. Take your time with shooting the footage you need. Be thorough and avoid rushing through your shoots. This takes planning and patience, but the final product will benefit from this style of shooting. Check all of your video footage and audio before you wrap. This ties into being complete with your shooting process. Lastly, shooting more gives you experience, and experience boosts your confidence. The more you shoot, the better you will become. Practice and perfect your skills, your craft will develop and your work will become refined. Shooting videos is meant to be fun, so if you enjoy it, it will translate in your art.

EXTRA FOOTAGE SAVES THE DAY
When it comes to editing your footage in post-production you'll likely find small errors of continuity or other small problems. At this point you'll be thanking your lucky stars for all of the B-roll you shot earlier, and using it to fill in any awkward areas.

POST-PRODUCTION

Post-production of videos produced with your DSLR is essential for a polished end product. The workflow will differ for everyone depending on which editing software you have, what applications you use and so on, but the general principles of post-production remain the same. For this reason, I'll only cover the basics of post-production in this section, and will also be using the programs and applications that we use for our workflow at OliviaTech for videos going straight to the web.

First things first, once you've shot your content, you must download all of your files onto a hard drive for storing. This process can become very complicated when you're dealing with multiple cards and cameras, so one thing I've learned while working with more than one camera and a plethora of memory cards is that clearly labeling each is essential for keeping it all organized. Keep your workflow consistent. This way you will always know exactly what is contained in your project folders and where it came from. Each CF card and each camera is clearly indicated within the footage folder. Each SD card containing audio is also clearly marked with date and project.
• Label all of your media
• Label all of your hard drives

File Management
Transfer data from your cameras and devices to the computer and hard drives.

For each project created, we label and date the file by year, day, and month, followed by an underscore and the project name, for example: 20120000_project name. Within each project file are ten

folders that contain all of the necessary information needed for any given production: audio, audio render files, documents, exports, footage, graphics, music, pictures, project files and render files. By keeping each category housed within one parent file, everything can be easily shared and transferred. By retaining the consistency of the folders, we know exactly what can be found within the project file for any given production.

Not only are the folders well organized, the contents inside each folder must also follow suit with the labeling style of each preceding folder. We also take advantage of the "label" option within each folder. By color coding your work you can systematically organize urgency, completed, incomplete, etc. Once all of the files have been properly organized and labeled, transfer to your hard drive. We also have a master hard drive where all content lives as a master backup drive.

Once everyone on your team is familiar with the project file management style, there should be no reason for important information being left out.

CHOICES IN POST-PRODUCTION
When it comes time to edit there is nothing more distressing than realizing there has been an unexpected problem with part of the footage. For this reason, it's always best to have lots of choice, so make sure you shoot as much material as possible to be able to fill any gaps.

The Basics

Getting the Best Results

Lighting & Audio

Basic Tools

Shooting Video

POST PRODUCTION

Editing Software

There is free, pre-installed software already included on most Macs and PCs: Windows Live Movie Maker and Apple's iMovie. For those of you who are only interested in minimal post-production operations, these programs will perform the basic tasks for getting your videos uploaded to video-sharing sites like YouTube or Vimeo and allow you to export and save your completed video onto a hard drive.

It is important to note that there is a difference between clip-based editing programs that requires you to trim each shot of your video to its beginning and end, then place it in order in sequence, and track-based editing programs like Final Cut Pro or Premier that allow you to view your video in terms of layers, which work much like Photoshop's layers, but stretched along a timeline. You don't necessarily need to use more than one track to achieve a very sophisticated-looking edit, but it's an advantage being able to overlay effects and graphics as you choose. The market perceives clip-based tools as easier to use, and this style of editing permeates the tools targeted at beginners, but it is clear and logical and perfectly adequate for many tasks, especially well-planned productions.

If you are looking to create professional, high-quality content and need greater control within editing, there are a wide variety of software applications available on the market. One that we use that has stood the test of time and trial is the editing suite, Final Cut Studio. Adobe's Premiere CS6, for example, can be used on both a PC and a Mac, whereas Final Cut Studio is compatible only with Mac. Both come with codecs that allow you to perform the transfers and edits you will need. These programs are more advanced and will grant you more capabilities to improve your completed video. I'll be using Final Cut Pro as my program of choice, but the workflow I'll take you through can be adapted to whichever program you decide to use.

Your level of investment in your software will reflect the features you need—some facilities are simply not offered by the less-expensive packages —but if you're starting out with video, the most important skills are simply trimming clips and placing them in order, something you can do with any editing program, including some that won't cost you a penny.

For those willing to spend a small amount on their software, there is a fiercely competitive market, with established names like Pinnacle Movie Studio, Sony Vegas Movie Studio, and an emerging leader, Adobe Premiere Elements, which is a reduced-feature version of Premiere in the same way that Photoshop Elements is a cut-down version of the leading pro image editor. This approach has been adopted by Apple, too, with Final Cut Express bringing much of the professional editing suite within reach of mere mortals.

Containers & Wrappers

A container, or wrapper, refers to the file format in which encoded data is held. There are many types of file format and most have specific purposes associated with computer programs. Some are created for a type of data—such as TIFF files, which only hold still-image data—while other, multimedia containers can hold different kinds of data.

The MOV file format, for example, is the standard QuickTime container developed by Apple, and the file type used by Canon DSLRs to shoot HD video, while Nikon cameras use the Microsoft-developed AVI file format instead. What both have in common is their ability to hold still images, moving images, audio data, or even a combination of all three.

Once you have chosen your camera, you have no choice over which file format is used to record your movies, as this is determined by the manufacturer. However, different containers have individual strengths and weaknesses, which can make a difference to the data it stores: the AVI container, for example, does not support features such as Variable Bit Rate (VBR) audio, meaning that any audio data will require more storage space.

Container Comparison

Below is a comparison of a .MOV video clip recorded in stereo, a .MOV clip recorded in mono, and an .AVI clip recorded in mono.

.MOV
(QuickTime)

H.264 Video codec

Stereo audio
Metadata

.MOV
(QuickTime)

H.264 Video codec

Mono Metadata

.AVI

Motion JPEG

Mono Metadata

The Basics

Getting the Best Results

Lighting & Audio

Basic Tools

Shooting Video

POST PRODUCTION

Codec & Converting

Now that you've shot and collected all of your video content onto memory cards, the next step is to get those files from your camera onto your computer in order to begin the editing process. The video files captured from your camera onto the memory cards need additional processing in order to edit them from your computer's post-production software. Codec stands for Compression-Decompression or Coder-Decoder.

A codec is a program that allows your editing software to decode your videos for editing then incode them for transfer to another location. If you are using Final Cut, you cannot import the files from your camera and begin to edit them directly on your editing software. You must first convert these files to allow them to be compatible with Final Cut.

If the container is the "box" in which data is held, the codec is the bit that orders the data and packs it into a nicely coded arrangement. The term "codec" is derived from two words—compressor and decompressor—which describe its ability to encode and/or decode the data in a file. There are essentially two types of codec—lossless codecs that compress data without losing any information, and lossy codecs that will compress the data, but discard some information in the compression and decompression process. In the same way that some containers are better suited to different types of content, so some codecs are designed to work better with certain tasks than with others. For example, the H.264 codec achieves high video quality at lower bit rates than some other codecs, but uses more processing power to achieve it. The result is that, while the codec works well for fitting data on the memory card or simply playing back video, it is not well suited to editing software as it takes more computing power to simply show the moving image, before you take into account transitions and other features. Many video-editing systems work far more smoothly if the video is converted to a codec specially designed for editing; these will have their data arranged to make it easier for the computer to display, but will likely require larger files. In Final Cut Pro the Apple ProRes codecs allow editing in real-time without having to wait for transitions to be rendered before playback.

H.264

H.264 is a compression that is an industry standard and used across the board for video compression. However, H.264 cannot go directly from the camera to your computer. Additional processing called converting is required. This brings us to converting software and why you need to install it prior to editing your videos.

Some editing software such as Sony Vegas and Final Cut Pro X, for example, will ingest the H.264 codec. I will only be using Final Cut Pro for my workflow example, as this is the editing software we use, and the industry standard.

Before you transfer the videos that you shot from your camera to your computer's editing software, you must first convert the H.264 codecs. Applications like Apple

The Basics

Getting the
Best Results

Lighting & Audio

Basic Tools

Shooting Video

POST
PRODUCTION

Intermediate Codecs

There are a surprisingly large number of codecs out there on the market, though your choices will be restricted by your software and platform choices.

Apple ProRes

The standard for Final Cut Pro, Apple bundle this with the software and it is more than adequate for top-quality editing jobs, though the files created are considerably larger than the original camera files.

Neoscene

A cross-platform codec available for Adobe Premiere, Final Cut Studio, Avid Media Composer, and Sony Vegas. It uses its own interpolation algorithm to recover from 4:2:0 to 4:2:2 chroma.

XDCAM

The XDCAM formats create files of a similar size to the camera originals, which can still be edited with easily.

Compressor, 5D RGB and Squared 5 MPEG Streamclip allow you to do this. While Squared 5 MPEG Streamclip is free, 5D RGB is limited in its free form and Apple Compressor is a paid application.

There are typically three main categories you must consider for the post-production process: converting, audio syncing, and editing. I will touch on all three for a general run through for you to follow.

Squared 5 MPEG Streamclip

I'll be using Squared 5 MPEG Streamclip for the converting workflow example.

Converting

1 Open your file, selecting all RAW movie files (H.264). When converting multiple clips, you will perform a batch edit. The next task you should perform is to convert your files.

2 Next, you will select Apple ProRes 422 (LT). ProRes 444 should be used if you intend to export for film or for very large, high-quality full-screen viewing. For web uses, Apple ProRes 422 (LT) is most commonly used. This step converts the H.264 codec to Apple ProRes 422 (LT) in order for the editing software to be able to read it.

3 File → Export Select the type of file you want to export to.

Macs automatically default to Apple Motion JPEG A and places your video quality at 50% with interlacing.

Here is how to change these specifications:

• Change your video quality to 100%.
• If your video was shot in progressive, you must deselect the Interlaced Scaling. Be sure the frame size is now set to 1920×1080 for full HD, or whichever frame size is needed for your project.
• Last, select Make Movie.

Syncing Video & Audio

Once you've converted all your video files, you can then begin the editing process. The very first thing you should do is to sync your audio with your video. PluralEyes is a program that will aid in the syncing process of your audio and video files. Rather than manually syncing all of your separate audio tracks, programs like PluralEyes does this tedious process for you. PluralEyes works in conjunction with your editing program to sync multiple tracks and shots. From my experience, this is one program that you really don't want to be without. You'll be syncing each audio file one at a time otherwise, which can be a very slow process. To avoid this, PluralEyes allows you to simply add all of your video and audio in a new sequence and then sync. It's that simple. PluralEyes works by comparing the audio tracks in a given sequence and then uses a proprietary algorithm to synchronize them. Anything that isn't able to sync up, you can manually do on your own.

You can also sync your audio files via auditory or visual cues in the editing process with the software application you are using. By visually looking for a spike in your video's audio waveform, you can align the audio clips with your video clips at the exact points to ensure perfectly synced audio. To do this, you must simultaneously slate or create a loud sound in both your audio and video. I explain this in detail in the audio section of the book.

Creating a New Project File

1 Create a new project file in your editing system where you can import your assets to.

2 In Final Cut Pro, this will be File → Import → Folder.

3 Import Audio and then import Video.

PLURALEYES

PluralEyes creates sequences of related files. This means that even if you've started and stopped your recording device multiple times and have shot multiple takes, PluralEyes will still sync up all of the audio files with the corresponding video files.

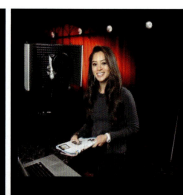

Create a sequence of all of the video and audio you want to sync. Lay these out in a timeline and select all. You'll then open PluralEyes and select sync.

At this point, PluralEyes converts all of the audio files to AIF files. First PluralEyes creates scratch reference files then the program syncs the waveforms from your audio and video files.

Sound tracking Your Video

Sound tracking your videos is a surefire way to add impact and emotion. Music can aid in telling your story and stir emotions within your audience. You must ensure that whomever has legal rights to the tracks that you include in your video has given you full legal consent to using them in your work. There are also royalty free music sites available on the Internet where you can find song libraries to soundtrack your video with.

Basic Editing of Your Audio Levels

First you want to turn on your clip overlay so you can visually see the pink rubberbands within your clip. These will guide you in this editing process. Using the Pen Tool, you will add keyframes or nodes to the audio waveform. These marks will indicate where you start and complete the areas in your timeline that you wish to alter. You can turn on the audio waveforms with the shortcut: Command Option W. After you have added your keyframes, switch to the Arrow Tool. This is used to adjust the decibel levels with your audio waveform. This can be done within any timeline to match volume levels or bring additional tracks to a desired level when used in conjunction with video.

The Basics

Getting the Best Results

Lighting & Audio

Basic Tools

Shooting Video

POST PRODUCTION

175

AUDIO EDITING WAVEFORMS

The graphic to the left shows what you'll see when you open your post-processing program to sync your audio and video. On top are the video clips, and below are the audio waveforms.

Editing Basics

Once you have synced your audio files as I have, using PluralEyes as an example, you can now begin to edit your video. I will touch on only the very bare basics to help you in understanding how to begin to build a sequence. For each editing program there is typically a user manual that will delve into deeper detail with the technical aspects of how to fully utilize the software.

Final Cut Pro has four main windows: Browser, Timeline, Viewer (preview), and Canvas (related to the timeline). Clicking on your clips will show them in the preview window. The canvas will always show where your cursor is within your timeline. Within the preview window, you can scroll through your video to see where you want to set your in and out points on the timeline.

In & Out Points

In and out points are markers that will indicate where each clip will start and stop. Setting the in and out points doesn't mean that you delete the video that falls outside these points, it just isn't used in the clip you transfer to the sequence. These are used as guiding points of reference to determine what areas of your clip will ultimately be used for editing into your timeline. Your selected clips make up the sequence or timeline.

Using I and O key as shortcuts makes this process faster. The canvas screen allows you to watch your newly edited timeline or sequence. You can also insert entire clips and drag in the edges to trim the clip to only the area you want to play.

IN & OUT POINTS
Here there are two clips, the in and out points marked in yellow, the scrubber in red/white (the scrubber is the point currently seen in the viewer).

Select	A	
Trim	T	
Position	P	
Range Selection	R	
Blade	B	
Zoom	Z	
Hand	H	

Insert & Overwrite

By dragging a selected clip and dropping it into the Insert area of the Canvas window, the clip will insert into your timeline. If you drag and drop a clip into the Overwrite area, this action visually puts the video on the top layer of the timeline and will trump any content below it unless you target a specific layer. Generally, the clip that is at the top layer of your timeline will play over anything below it.

Rendering

When you change the values of a clip, you must then render it in order to play. If you have a clip that is a different codec, it must be rendered. There will be a red bar at the top of your timeline that will indicate this. You can render a clip by clicking "sequence" in the main menu.

Post-processing Controls

The above tools are from Final Cut Pro X, but most post-processing programs for video will have similar tools with similar functionality.

Select
Selects the clip to be worked on, moves it by clicking and dragging.

Trim
Trims/expands clips in various ways and moves around a clip within the in and out points.

Position
Moves a selected clip over the clips that precede or follow it without expanding other areas.

Range Selection
Set in and out points on the timeline with the ability to move them around.

Blade
Cuts or separates clips.

Zoom
Zooms in on the timeline.

Hand
Allows you to move around the timeline—useful for working while zoomed in.

Building a Sequence

Cutaway

A cutaway is a cutting technique that breaks up continuous footage. Inserting supporting footage into continuous footage creates a cutaway. Cutaways serve to provide your audience with more information or a different perspective. You want your cutaways to make sense and not leave your viewer pondering the relevance of the inserted shot. Make sure the cutaway makes contextual sense for your video.

Jump Cut

A jump cut will disrupt the continuity of your video. This type of cut brings two shots of the same subject together with varying camera angles. The video appears to jump. This style of editing can be distracting to the viewer and appears very unprofessional.

L Cuts

When telling a story, sometimes you will want to give deeper context or insight into the subject that is being presented. An L cut does this by transitioning from

POST-PROCESSING

The below graphic illustrates what your post-processing program is likely to look like when you are building a sequence. Illustrated are a number of cuts where a clip ends and the next scene in the sequence begins. Note the accompanying voiceover also.

one shot into another, while the audio remains consistent.

Transitions

When combining clips, your transitions are what marry the two together. There are many techniques to incorporating transitions in video. These can be as simple as straight cuts from one clip to the next. Getting creative with transitions can add to the storytelling and set a mood or tone to a video. Transitions can also include audio to make videos more dynamic. It all depends on what type of video you are trying to create.

Continuity

Keeping continuity within your videos is important to telling stories that make sense to your audience. When editing lacks continuity, the story loses purpose and can become confusing. Keeping continuity within conversation, space, time and so on is something you must be aware of when editing your video.

CONTINUITY IN A SEQUENCE

Small changes made in the editing room can cause confusion for the viewer, especially with regard to the position of objects. In the series of shots below, the eyeglasses stay in much the same place—it's best to have one person responsible for continuity on a shoot, but as an added precaution watch out for continuity issues when building your sequence.

The Basics

Getting the Best Results

Lighting & Audio

Basic Tools

Shooting Video

POST PRODUCTION

Color

S adly, many people now refer to color grading simply as color correction, but that somewhat diminishes its purpose. The latter emphasizes the importance of imposing consistent color across clips, but with skilled use the same tools can be used to subtly alter the tone of a clip too.

If you want to be creative with color, it's likely you have a plan for altering the tone and color of your footage—for example, to add an orange hint in order to make the picture seem candlelit and warm. That's certainly something that you can do with these tools—that's the "grading" aspect, if you like—but the correction is key, and equates more directly to using the Levels or Curves tools in Photoshop to make sure that first, you've got a good shot, and second, that your subsequent shots match it.

If you had a lighting disaster, for example, and switched to a different color temperature, you can also make this change here. If you remembered to use a gray card or color checker, it's as simple as clicking on the eyedropper icon and then on the mid-gray. If, however, you've been lazy at the point of capture, you will pay for it now by having to grade all your clips independently and try to get them to match.

Color Grading

When you alter, enhance, and change the color of a photo or video, this is color grading. In the post-production process, editors will color grade to give a certain look to the film or enhance certain colors

SATURATION INTERFACE

for impact. Especially in the event that you are shooting with your picture style set in no contrast and no saturation, the final image result is going to be very flat in color. This is done intentionally to give the editor more room in post-production to treat the colors as desired, giving you much more coloring control.

Color Correcting

Color correcting in production is when you intentionally change the temperature of light in order to correct its overall appearance. Color correcting in post is the act of changing the temperature of the scene or image in order to alter the color. Software makes this possible in the post-production process, but it is best practice to do this on-set while in production and clean up any minor color alterations in post, rather than depending on the post work to properly color and light the scenes for you.

COLOR INTERFACE

EXPOSURE INTERFACE

Whites, Mid-tones, and Blacks

Within a three-way color corrector user interface, you'll be presented with three different color wheels. One for blacks, one for mids and one for whites. Each has a reset button so you can always revert your work back to its original state. By holding down the command key, you can move your mouse and get a quick read of what changes you are making to the color of your clip. The eyedropper is the tool that will allow you to auto balance the areas that you want to change to true black or white. Once you select the eyedropper tool from your black or white color wheel, you will then click on the correlating color in your selected clip. Final Cut Pro will then correct any casts in your blacks and whites.

Saturation Slider

You can adjust your saturation with the saturation control by pulling the slider left or right. By adjusting the levels within the three-way color corrector interface, you can correct the color of one clip to match another. Using the vector scopes will ensure a true match versus simply eyeballing the colors. This is also the area that will allow you to color grade.

The Basics

Getting the Best Results

Lighting & Audio

Basic Tools

Shooting Video

POST PRODUCTION

181

Finishing Up

The final part of the post-production process is exporting your completed video. Depending on what destination you want to export your media assets to, this process will vary.

Export for Computer Viewing

Obviously your computer is capable of displaying video if you've got as far as completing an edit, but as part of the process it was likely transcoded to a space-consuming format. When you're preparing the file to be viewed on the computer—or computers—you will be looking to use an established, but efficient codec. The aim is for the video to be as compact as possible, while maintaining the maximum quality. If you're planning on distributing your video, you need to be aware that the highest quality that your computer can play might be a little out of reach for others, so if you're going to send the video to relatives, for example, consider tweaking the settings to reduce the resolution—or, if you have to, halve the frame rate—which will make the video considerably less processor-intensive. Changing the level of compression without changing the method will likely have little effect on required power; H.264 requires more CPU power than MPEG 2, but is less space-efficient.

Within a specific codec, this change of compression is usually thought of in terms of bitrate, which can either be fixed or variable. In the latter case, when you encode the video the computer will endeavor to use a lower rate when there is less action, and therefore less changing

detail, on the screen. In the H.264 examples shown here, the bitrate is expressed as 0–100% (the minimum and maximum allowed by the specification).

Export for the Web

Once you've edited your movie, one of the widest-reaching distribution methods available to you—and certainly one of the easiest—is the internet. However, publishing online can also be problematic. Although the content is still your copyright, it is hard to protect, and it is easy for people to take it and reuse it. This

should not put you off using the internet as a means of distributing your movies, but you need to be aware of the risks so you can try to minimize them. There are lots of websites where you can post your videos, but the two most commonly used at the time of writing are Vimeo and YouTube, both of which will host high-definition, 720p footage, as well as standard-resolution video.

For exporting for the web, first select File > Export. Select the type of file you want to export to. A Save File box will then appear. Name your project file and choose the destination you wish your video to export to, then hit save.

Exporting to the Web

The settings we use for exporting to the web are:
- Compression Type → H.264
- Key Frames → Current
- Select Frame Reordering
- Compressor → Quality → High
- Encoding → Best Quality (Multi-Pass)
- Data Rate → Restrict → 5000 kbits/sec
- Optimize → Streaming
- Dimensions for full HD video → 1920×1080

Sound Settings
- Format → AAC
- Channels → Stereo (L R)
- Rate → 44.100

Render Settings
- Quality → Normal
- MPEG 4 AAC LC Encoder Settings
- Target Bit Rate → 320

Online Video Sites

These are the settings for the two leading online video sites for uploading HD video:

YouTube
H.264, MPEG-2 or MPEG-4 encoding
720p resolution
44.1KHz Stereo as MP3 or AAC/WAV
Use original frame rate
Max. file size 1 GB/10 minutes

Vimeo
MP4 preferred container
H.264 encoding (5000bps)
720p or 1080p resolution
44.1KHz AAC/WAV stereo (320kbps)
Use original frame rate
Max. file size 1 GB/10 minutes

This is a general overview of the settings we use when exporting for the web with Final Cut Pro. After the export is completed, the movie file is then saved to a hard drive and can be uploaded to the web

Export for Viewing on a Television
Many computer monitors are a slightly squarer 16:10, rather than 16:9, in their proportions, which means that very small black bars will appear at the top and bottom of the computer screen when viewing HD video.

Though it's your choice, if the video is only likely to be viewed on computer, 720p resolution rather than 1080p is often sufficient, as the monitor is rarely the exact same pixel dimensions as a 1080p TV, so some scaling, with slight softening effect, will occur anyway.

The Basics

Getting the Best Results

Lighting & Audio

Basic Tools

Shooting Video

POST PRODUCTION

GLOSSARY

ACG
Automatic gain control adjusts the gain control for high or low signals coming into the sound recording device automatically.

ALIASING
When the camera skips lines and leaves out some information. The high spatial frequency can result in terrible moire interference patterns that create what looks like moving lines.

AMBIENT
Ambient or ambience consists of the background sounds within a given space.

APERTURE
The aperture is measured by the size of the iris within the lens. This iris is an opening that controls the amount of light that passes through to the sensor.

B-ROLL
Supplemental footage that is intercut into the main shot to assist with creating a visually interesting piece and convey more information into the story.

BACKLIGHT
Used to separate the subject from the background by adding dimension, contrast, and introducing a highlight around the rim of the subject.

BATTERY GRIP
A battery grip is a battery extension that attaches onto the camera to add life-span to its working time.

BOKEH
The aesthetic quality of the blur that makes up the out-of-focus points of light in an image.

BOOM
A technique where the microphone is attached to a boom pole and held out at length and as close as possible to the sound source. The microphone is suspended either overhead or underneath the subject.

The Basics

Getting the Best Results

Lighting & Audio

Basic Tools

Shooting Video

Post-production

CARDIOID MICROPHONE
A cardioid microphone has a heart-shaped pick-up pattern and is best suited to pick up sounds from the front.

CATCHLIGHT
Catchlights are points of a light source or multiple light sources that are reflected by the subject.

CROP FACTOR
Crop factor refers to the ratio of the dimensions of the camera's imaging area using the 35mm film standard dimension as a comparison reference.

CODEC
Compression-Decompression or Coder-Decoder is a program that allows your editing software to decode your videos for editing then incode them for transfer to another location.

COLOR CORRECT
Intentionally changing the temperature of light in order to correct the overall appearance of an image to alter the color.

COLOR GRADE
Altering, enhancing, and changing the color of an image in order to give the final image a certain look.

DEPTH OF FIELD
The out-of-focus distance that is in front of and behind the plane of sharp focus.

ELECTRONIC VIEWFINDER
A very small monitor in combination with a magnifying loupe to assist in accurate focus and color.

F-STOP
The ratio of the lens's focal length to the diameter of the aperture size. *f*-stops are like fractions: moving from one to the next will either double or reduce by half the amount of light entering.

FIELD MIXER
Provides the ability to mix multiple audio sources, adjust individual microphone levels and supplies a preamp for an improved signal to noise ratio when recording audio.

FILL LIGHT
The fill light acts as a filler of light in the darkened shaded areas where the key light cannot illuminate.

FOCAL LENGTH
The distance between the optical center of a lens and its point of focus when the lens is focused on infinity. Focal length determines how much

magnification the lens provides.

FLAG
Prevents light spill from illuminating unwanted areas. Flags direct the light and keep it contained in only the area that is intended to be lit.

FOLLOW FOCUS
A specially designed geared system that makes contact with the focus ring of the lens, usually via a lens gear. A follow focus system assists the operator in pulling smooth and accurate focus more ergonomically.

FRAME RATE
The rate at which the camera produces its frames per second when shooting video.

H.246
H.264 is a compression that is an industry standard and used across the board for video compression. However, H.264 cannot go directly from the camera to your computer. Additional processing called converting is required.

HYPERCARDIOID
Hypercardioid microphones are very similar to cardioid microphones, but they have an even tighter, more exaggerated pick-up pattern.

ISO
International Organization for Standardization, or ISO expresses how sensitive the image sensor is to the amount of ambient light present.

KELVIN TEMPERATURES
Measures the relative warmth or coolness of white light. At a high temperature, 5000–7000 degrees K, the light seen is white. Once the Kelvin temperature dips down in the lower numbers, less than 5000 degrees K, we see warmer tones and reds.

KEY LIGHT
The main light used to light a subject. The key light is typically positioned so that it illuminates as much of the subject from the front view as possible.

LAVALIER MICROPHONE
A lavalier microphone typically clips onto the lapel, tie or shirt of your subject.

MATTE BOX
Controls the light entering the camera's lens in order to prevent lens flare. Matte boxes can include flags at the top and/or sides to block light that the matte box may not be deep enough to prevent entering into the lens.

NOISE
In audio, this is the unwanted signal that exists within the environment. The noise present will reduce the clarity of the signal you intend to capture.

OMNIDIRECTIONAL
An omnidirectional microphone has an even pick-up response in all directions.

OPTICAL VIEWFINDER
Also called a loupe, this is an attachment that connects to the camera's LCD display to provide a magnified perspective while preventing extraneous light leakage.

PHANTOM POWER
Phantom power means that the audio recording device will need to be powered by whatever it is plugged into. Some devices will provide phantom power by generating the required voltage.

POLAR PATTERN
The polar pattern of a microphone refers to the different types of directional response patterns that the microphone has. A polar pattern is designed to show you which directions a microphone will pick sound up from.

PREAMPLIFIER
A preamplifier will throttle back the noisy amplifier in your camera and replace the noisy gain with clean gain.

PRIME LENS
A lens with a fixed focal length.

The Basics

Getting the Best Results

Lighting & Audio

Basic Tools

Shooting Video

Post-production

PROXIMITY EFFECT
The proximity effect is audio distortion that results in an increase in bass frequencies.

RACK FOCUSING
Shifting the focus point from the subject in the background to the subject in the foreground or vice versa. This technique intentionally directs the viewer's attention.

ROOM TONE
Room tone is unique and determined according to the position of the microphone in relation to the surrounding spatial boundaries.

ROLLING SHUTTER
When referring to video recording on a DSLR, the information captured is recorded to the sensor line by line by a series of scans. This is done by rolling the shutter across the image area that is being exposed. The entire image area is not exposed at the same time. This method allows for more sensitivity to the camera's sensor.

SCRIM
Made of metal and acts as a screen that is typically mounted in a metal frame. A scrim is placed in front of a light source to reduce the light's intensity.

SIGNAL
In audio, the signal is the meaningful information that is intended to be communicated.

SHOTGUN
A shotgun microphone is the most highly directional type of microphone with a very narrow pick-up pattern.

SHUTTER SPEED
The length of time that the shutter is opened and allows light to hit the camera's image sensor.

THREE-POINT LIGHTING
Lighting a subject using three separate positions. Standard three-point lighting consists of a key light, a fill light, and a backlight.

WHITE BALANCE
A process of removing incorrect color casts for balanced exposure and color.

ZOOM LENS
A lens with a variable focal length. Zooms will give you a range of different focal lengths all in one single lens.

Index

A

AC power adapter 87
aliasing 165
ambient light 39, 123
ambient noise 53
aperture 9, 10, 104–5,
 117
 closed down/small
 9, 157
 low light 152
 wide open/large 9, 156
Apple ProRes 172, 173
APS-C camera 28–9
aspect ratio 25
audio 52
 ambience 53
 automatic gain control
 (AGC) 63, 65
 clipping and gain 62–3
 compression 63
 documentary video
 124–5
 editing 175
 electronic news
 gathering 112–13,
 115
 external recorder 62–3
 fader 64
 field mixer 64, 112, 131
 headphone output 80
 headphones 113, 115,
 118, 124
 limiter 64
 mono sound 54
 narrative video 131
 phantom power 63
 preamplifier 17, 23, 65,
 125
 presence/room tone

 53, 131
 signal 52
 signal-to-noise ratio
 (SNR) 52, 54, 112
 stereo sound 54
 syncing with video
 62, 174–5
 tone 64
 tutorial video 118
 wedding video 108, 109
 windscreen 113
 see also microphone
Auto Power Off 22
available light 39, 123

B

B-roll 100, 101, 109,
 117, 122
background 35
 all black 140–1
 chroma key 142–5
 infinite white
 138–9, 147
 light 45
 white paper 117, 119
barn doors 41, 45
batteries 86–7, 114
battery grip 86
black foil 41
blimp 59
bokeh 9
boom pole 60, 61, 112
brightness display 24

C

C47 45
cage 75, 77, 114, 115,
 118, 123
camera slider 82

camera types 18–19
Canon lenses 117
card case 93
card reader 93
cardioid microphone 57
case studies
 documentary 120–5
 editorial 110–15
 electronic news
 gathering 110–15
 music video 132–7
 narrative 126–31
 tutorial 116–19
 wedding 102–9
casting 97
catchlights 48–9, 136
CF (compact flash)
 card 92
CFLs 42, 118, 139
checklists 99, 122, 133
chroma key 142–5
circular polarizer 31
clamps 76
clapper slate 66–7, 127
close-up 33, 117
clothes pin 45
CMOS sensor 11
codec 172–3, 182
cold shoe adapter 90
color 133, 180
 correcting 44, 180–1
 False Color 80
 filters 30
 grading 180
 saturation slider 181
 wheel 134, 180
Color Space 21
color temperature 12
 blue (CTB) 44, 118

 correcting 44, 180–1
 orange (CTO) 44
 plus and minus
 green 44
 styling gels 44
colored gels 44
composition 34–5, 127
containers 171
continuity 179
counterweight 77
crane 82
crop factor 28–9, 106
cutaway 100, 101, 178

D

depth of field 9, 30, 105,
 151, 156–7
digital zoom 150
 documentary video
 120–5
 audio 124–5
 B-roll 122
 camera cage 123
 equipment checklist
 122
 gathering footage 125
 lighting 123
 microphone 124–5
 permission 121
 pre-production 120–1
 preamp 125
 research 121
 rig 122
 scouting 121
 setup 122
 tripod/monopod 123

E

editing

audio 175
 insert and overwrite 177
 in and out points 176
 post-processing controls 177
 rendering 177
 software 170
 wedding video 109
electronic news gathering (ENG) 110–15
 audio 112–13, 115
 compact spaces 114–15
 crew 111
 electronic viewfinder 80, 110
 event camera rig 110
 follow focus 111
 friction arm 111
 lighting 113, 114
 matte box 111
 shotgun microphone 111
 windscreen 113
electronic viewfinder (EVF) 19, 80, 81, 110
Electronic Viewfinder Interchangeable Lens (EVIL) 6, 19
exporting 182–3
external hard drive 92–3
external monitor 78–9, 117, 130
eye reflections 49
eyeline 35

F

f-stops 9

False Color 80
FAT32 file systems 16
field mixer 64, 112, 131
file management 16, 166, 169
fill light 46
filters 30–1, 81, 165
 circular polarizer 31
 color 30
 diffusion 44
 step up/down adapters 90
 ultra violet 30
 see also ND filters
Final Cut Pro 170, 172, 173, 174, 176, 177, 181, 183
flag 41
FLM see crop factor
flood lights 39
focusing while shooting 150–1
follow focus 78, 79, 111
 marking 151
frame rate 10, 11
framing 32–3, 127
friction arm 88, 111
friction slider 82
full frame camera 28

G

gaffers tape 89, 119
gathering footage 100–1, 117, 125
Gini Rail System 117
Glidecam 85, 107, 161, 162
Google Docs 97
grain 13, 153
gray card 14

grip 77, 86, 88–9, 119

H

H.264 codecs 172–3, 182
halogen lamps 43
handle 77
head room 34, 35
headphone output 80
headphones 113, 115, 118, 124
Highlight Tone Priority 22
hotshoe 90
hypercardioid microphone 57

I

Image Jump 22
image stabilization (IS) 29
infinite white background 138–9, 147
information display 24–5
interlace resolution 25
ISO settings 13, 104
 expansion 23
 low light 153
 noise reduction 23

J

jello effect 11, 164, 165
jib 83, 136
jump cut 100, 178

K

Kelvin temperatures 12, 21, 104
key light 46

kick/kicker light 47

L

L cuts 178–9
lavalier microphone 59, 108, 115
LCD display 23, 24, 117
lead room 34, 35
LED lights 38, 43, 78, 114, 123, 129
lenses 26–7
 Auto Focus 27
 Canon 117
 crop factor 28–9, 106
 fisheye 134
 focal length 26–7
 lens care kit 90
 long 146
 macro 117, 134
 music video 134
 narrative video 128
 portrait 134
 prime 27
 telephoto 27
 tutorial video 117
 wedding video 105–6
 wide-angle 26, 134
 zoom 27, 117, 128
light meter 14–15
lighting
 ambient light 39, 123
 backlight 46–7
 catchlights 48–9, 136
 CFLs 42, 118
 color correcting 44
 diffused light 38, 39
 diffusion gels/filters 44
 directional light 39
 documentary video 123

The Basics

Getting the Best Results

Lighting & Audio

Basic Tools

Shooting Video

Post-production

electronic news
gathering 113, 114
fill 46
flood lights 39
four-point 47
halogen 43
hard light 38–9
infinite white
background
138–9, 147
key 46
kick/kicker 47
LED 38, 43, 78, 114,
123, 129
low light 129, 152–5
mood 155
music video 134, 136
narrative video 129,
130
open-faces lights 40
ReflecMedia LiteRing
144–5
reflector 50–1
rim light 46–7, 136
ring light 48, 49
soft light 38, 39
softbox 38, 40, 49, 118
special light 45
three-point 46–7
tutorial video 118
live histogram 24
Live View 6, 23
location monitor 80
loupes 80–1, 114
Lowell Omni hotlight 118

M

magnetic fastener 88
Manfrotto 501 Video Fluid

Head 114
matte box 81, 111
memory 92–3, 108–9
menu setup 20–3
Micro Four Thirds 6, 29
microphone 17, 23, 54
blimp 59
boom pole 60, 61, 112
cardioid 57
directional 56
documentary video
124–5
electronic news
gathering 112–13
hypercardioid 57
lavalier 59, 108, 115
omnidirectional 56, 58
orientation and
mounting 60–1
pistol grip 61, 115
plant 61
polar pattern 54, 56–7,
112–13
proximity effect 57
Rode VideoMic Pro
112–13, 124
shock mount 58,
60, 61, 124
shotgun 57, 58, 111,
112, 115, 124
tutorial video 118
windscreen 59
see also audio
MILC (Mirrorless
Interchangeable-lens)
cameras 6, 19
mode dial setting 20
monopod 72, 74, 106,
123, 158

mood lighting 155
movie recording size 23
music video 132–7
checklists 133
color 134, 137
gear 136
lenses 134
lighting 134, 136
pre-production 132
scouting 133
storyboard 132

N

narrative video 126–31
audio 131
director's slate 127
external monitor 130
framing and
composition 127
lenses 128
lighting 129, 130
pre-production 126
ND (neutral density) filters
10, 11, 30, 103
variable 30, 103
Neoscene 173
noise 13, 23, 52–3, 153

O

open-face lights 40–1
optical viewfinder 80–1

P

pan and tilt 29, 73,
115, 164
peripheral illumination
correct 20
permits 98, 121
perspective 164, 165

phantom power 63
pistol grip 61, 115
PluralEyes 174–5, 176
pre-production 96–9
documentary video
120–1
music video 132
narrative video 126
tutorial video 116
wedding video 102
preamplifier 17, 23,
65, 125
product video 146–9
production 100–1
progressive resolution 25
proximity effect 57
pulling focus 79

R

rack focusing 151
ReflecMedia LiteRing
144–5
reflector 50–1, 113
resolution 24–5
RGB display 24
rim light 46–7, 136
ring light 48, 49
Rode VideoMic Pro
112–13, 124
rods 76
roller bearing slider 82
rolling shutter 11, 164,
165
rule of thirds 34

S

sandbags 89, 119
saturation slider 181
Savage Seamless white

paper 117, 119
scouting 98–9, 121, 133
scrim 45
script 96–7, 116
SDHC card 16, 92
Sennheiser Evolution
 Wireless Microphones
 and Receivers 115,
 118, 124
sensors 9, 11
 cleaning 23, 90
shade 50
shadows 38, 39, 45, 46,
 47, 49, 50
shock mount 58,
 60, 61, 124
shotgun microphone 57,
 58, 111, 112, 115, 124
shoulder mount 76–7
shutter speed 10–11
 low light 154
signage 100, 101
sliders 82, 107, 136,
 159–60, 181
SmallHD Dp4 117
softbox 38, 40, 49, 118
Squared 5 MPEG
 Streamclip 173
stabilizers 85, 107, 136

flying 84, 85, 161–3
vest system 85
Steadicam 85, 107
step up/down adapters 90
storyboard 96, 116, 127,
 132
stylizing gels 44
super clamp 88–9
syncing video and audio
 62, 174–5

T
table dolly 84
Tekkeon battery pack 87,
 114
telephoto lenses 27
teleprompter 118
tracking shots 160
transitions 179
transportation 91
tripod 69–75, 107, 114,
 117, 123, 146–7
 ball head 75
 bowl mount 70, 71, 117
 buying 74
 fluid heads 72–3, 74,
 114, 146–7
 positioning 71
 quick-release (QR) plate

74
regular mount 70–1
tutorial video 116–19
 audio 118
 backdrop 119
 camera and rig 117
 external monitor 117
 gathering footage 117
 grip 119
 lenses 117
 lighting 118
 pre-production 116
 support 117
 teleprompter 118–19

U
UV (ultra violet) filters 30

V
VAF-5D2 165, 166
Varavon Profinder 114,
 115
velcro straps 89
video rig 76–81

W
wedding video 102–9
 aperture 104–5
 audio 108

B-roll 109
camera settings 103
 editing 109
 ISO setting 104
 lenses 105–6
 memory 108–9
 monopod 106
 pre-production 102
 shutter speed 103
 sliders 107
 stabilizer 107
 tripod 107
white balance 12, 21, 104
 correction 14
 custom 14–15
white paper 117, 119
wide-angle lens 26, 134
wrappers 171

X
XDCAM 173

Z
zoom lenses 27, 117, 128
Zoom recorders 108, 112,
 115, 118

The Basics

Getting the
Best Results

Lighting & Audio

Basic Tools

Shooting Video

Post-production

Acknowledgments

AUTHOR'S ACKNOWLEDGMENTS

The OliviaTech team: The support and knowledge I've received from you guys has been immense and priceless. I appreciate you all beyond words. All love and many thanks, boys!

My family: Thank you for putting up with all of my crazy ideas. One day they all won't be so crazy anymore—I promise. I love you!

The cheesycam.com family: The level of love and gratitude I have for you runs deep. Thank you for always being in my corner and for believing in me since the beginning.

Kayko Tamaki: You have given me endless amounts of love and support ever since we crossed paths. Thank you for your time and your talent. I love you.

Livia Chu: Hanging out in the rain on your work days, lending your time to this project, laughing until it hurts—thanks for it all, Liv. You have given me a huge amount of support. I love you.

Adam, Natalia, Tara, and the Ilex team: This book would not have happened without you all. Thank you for this opportunity, your support, and seeing this project through with me. Many thanks and so much appreciation for all of your talents.

PICTURE ACKNOWLEDGMENTS

Photographers:

Leonardo De Asis Jr.

Emm at cheesycam.com

Olivia Speranza

App Videographers:

Leonardo De Asis Jr.

Emm at cheesycam.com

App Video Editor:

Larry Alfonso

PICTURE CREDITS

Fotolia: p2, p37, p43 (right), p45 (both), p69, p86 (top), p164, p168, p179.

Photocase: p4, p28, p185.

Image p97 © Lamar K Foto.

Ilex Press would like to extend its thanks to all of the manufacturers whose products appear in this book, including Nikon, Canon, Lumix, juicedLink, and Varavon.